me

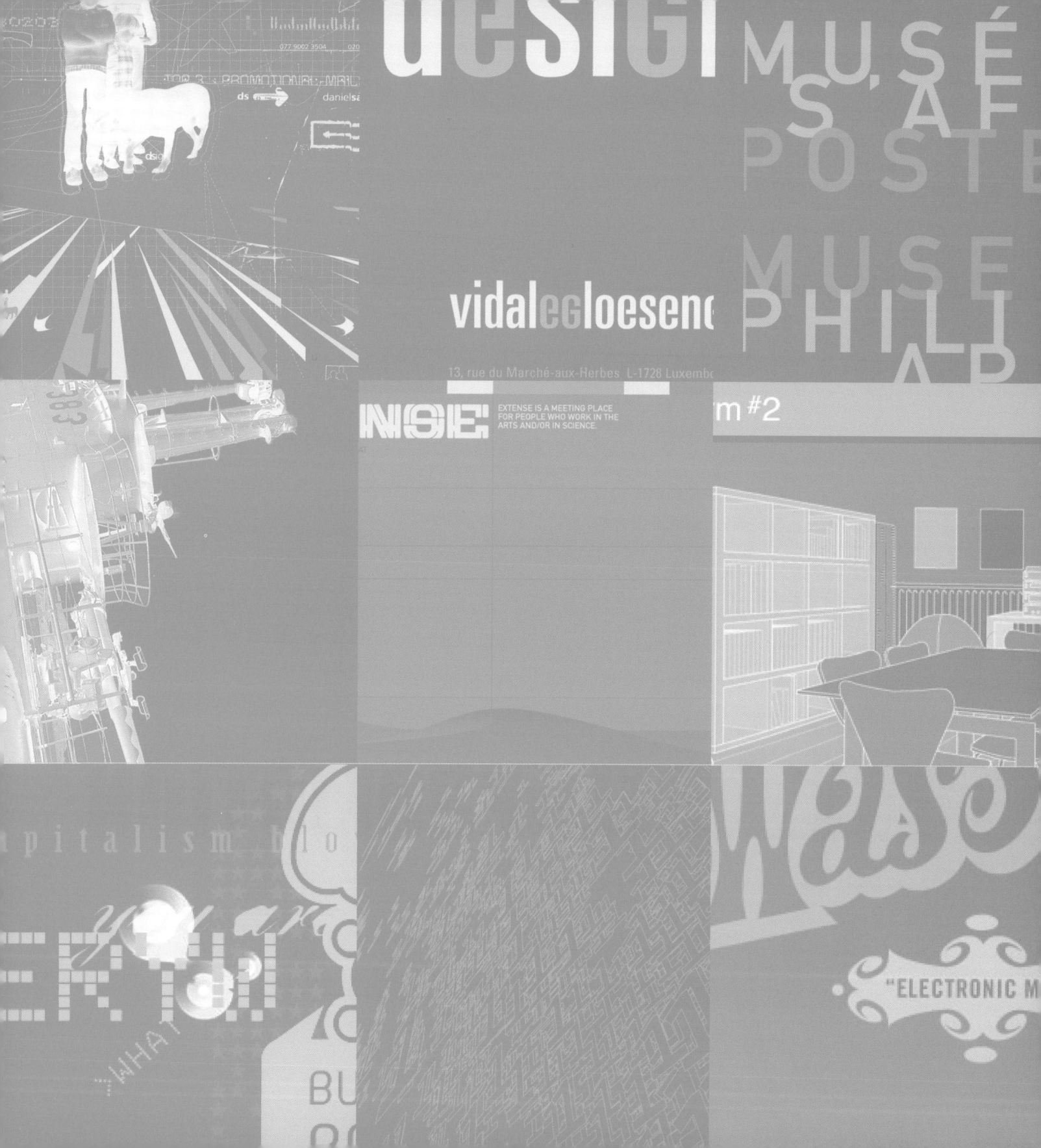

DESIGNERS'
SELF PROMOTION

HOW DESIGNERS AND DESIGN COMPANIES ATTRACT ATTENTION TO THEMSELVES

DESIGNERS' SELF PROMOTION

First published in 2002 by:
HBI, an imprint of HarperCollins Publishers
10 East 53rd Street
New York, NY 10022-5299
United States of America

Distributed to the trade and art markets
in the U.S. by:
North Light Books,
an imprint of F&W Publications, Inc.
4700 East Galbraith Road
Cincinnati, Ohio 45236
Tel: (800) 289-0963

Distributed throughout the rest
of the world by:
HarperCollins International
10 East 53rd Street
New York, NY 10022-5299
Fax: (212) 207-7654

ISBN: 0-06-621355-X

Copyright © HBI and
Duncan Baird Publishers 2001
Text copyright © Duncan Baird Publishers 2001

All rights reserved. No part of this book may
be reproduced in any form or by any electronic
or mechanical means, including information-
storage and retrieval systems, without
permission in writing from the copyright
owners, except by a reviewer who may
quote brief passages in a review.

Conceived, created, and designed by:
Duncan Baird Publishers
6th Floor, Castle House
75-76 Wells Street, London W1T 3QH

Designer: Lloyd Tilbury at Cobalt id
Editor: Marek Walisiewicz at Cobalt id
Project Co-ordinators: Kelly Cody and Tamsin Wilson

10 9 8 7 6 5 4 3 2 1

Typeset in RotisSansSerif
Color reproduction by Colourscan, Singapore
Manufactured in China by Imago

NOTE
All measurements listed in this book
are for width followed by height.

CONTENTS

FOREWORD_6
WORK_8
INDEX_142

FOREWORD

They say there's no such thing as bad publicity, but when it comes to self-promotion the pitfalls are wide and deep. Designers and design companies face a special challenge because every self-promotional item they produce – every brochure, web page, flyer, poster or artifact – is also an example of their work, a showcase of their creative talent.

When self-promotion misfires, the results can be disastrous. Poor design judgement, an inappropriate concept or a badly timed mailing can all alienate existing clients or deter good prospects. On the other hand there is no doubt that confident, original promotional work that intrigues and entices can be the first step in a long and fruitful relationship.

This unrivaled collection of work from design studios around the world shows a wide range of solutions to the thorny, perennial problem of self-promotion. The freshness and diversity of approach reveals that although everyone is saying essentially the same thing – ME, ME, ME – there are near-infinite ways of saying it.

This book is intended to inspire, inform, and amuse. It is an essential reference for graphics professionals and students and an original sourcebook for anyone who commissions design or is simply fascinated by the creative process.

RW

WORK

Throughout this book, the work of each studio or designer is laid out on one or two double page spreads. A brief text description lists the items on each spread and gives their dimensions.

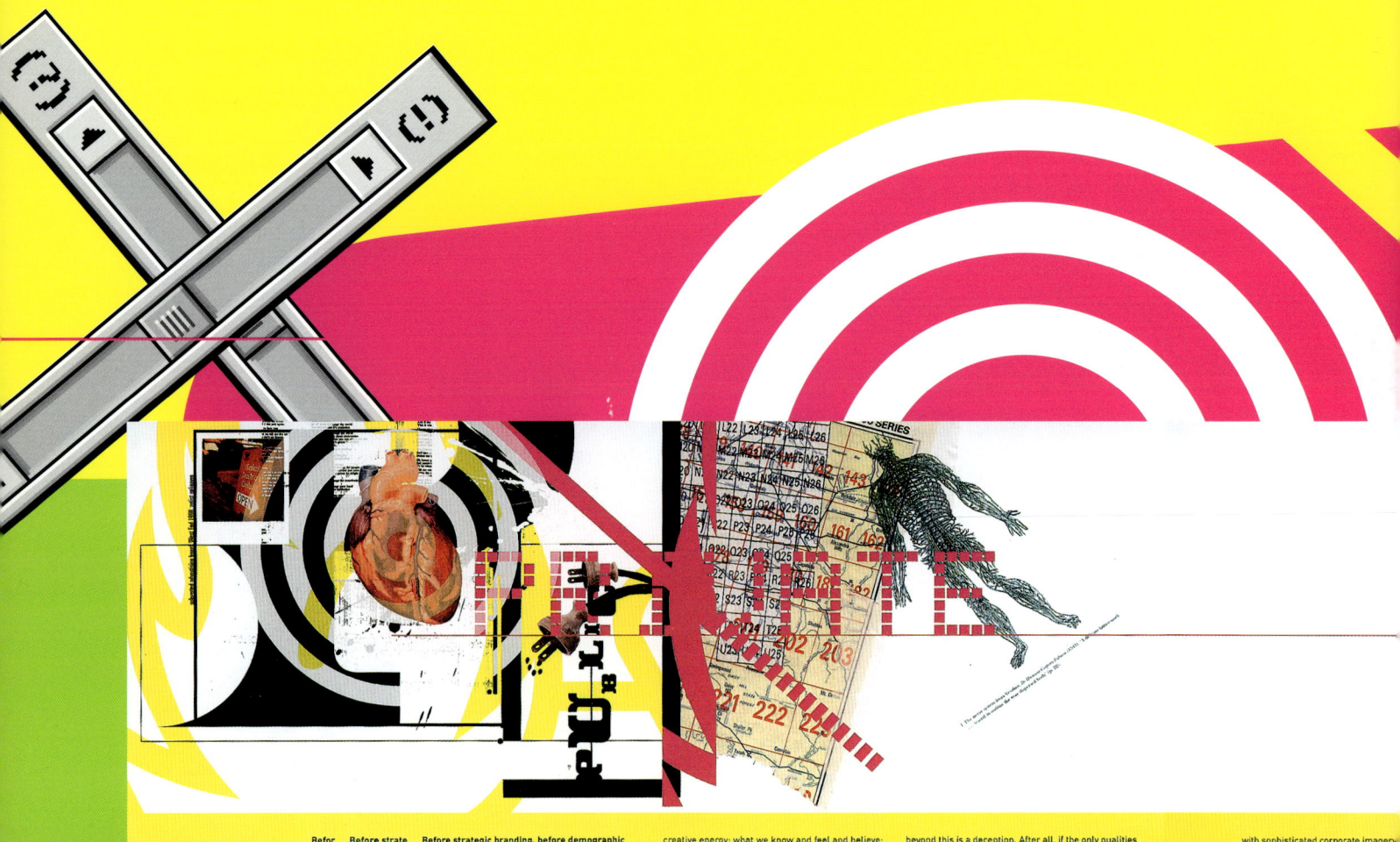

Before strategic branding, before demographic analysis and lifestyle quantification, before modernism verses postmodernism, and long before Pepsi sponsored stadium rock tours, is a weird, sliding feeling in the gut. A completely subjective but undeniably real physical trespass on habit guarded senses. A rare moment of elevation to a strange truth. This is where it starts. A Ken Miki poster. A painting by someone called Jasper Johns or Velazquez, or by someone called Picasso. A Jenny Holzer electronic billboard. A Vaughn Oliver record cover. In a school library. In a record store. On the street. An encounter that itches to be reborn. Designers crave to provoke these moments with our own work – often before we are even aware there is a profession that can accommodate us. Truthfully, how many designers only burn to shift a unit, or grow a profit?

The tension between private and public is a fundamental creative energy: what we know and feel and believe; and on the other hand what the weather's doing and who's running the country. Our work reconciles this dialogue between the stuff inside us and the world around us by finally stepping blinking from the shade onto the bright glare of the page or the screen.

This book is intended to gather together projects that have excited, humoured, frustrated, enriched and inspired us, and we hope, equally engaged our audience.

The client isn't mentioned here, not of course because they're unimportant, but because there is a balance to be redressed. Contrary to the popular premise of commercial visual communication we don't necessarily see our role as selling the client's product. Hopefully they don't need us for that. We figure the unique qualities of their product or service should sell itself. Our role is to communicate these qualities because anything beyond this is a deception. After all, if the only qualities that differentiate a product are superficial elements of contrived visual seduction, then in a world of rapidly dwindling natural resources, maybe it shouldn't even exist? (OK, so if you're a multinational softdrink manufacturer thinking of hiring Inkahoots, we accept you've probably lost interest by now.)

Inkahoots doesn't quite fit into any of the usual industry moulds. Sometimes this helps the business, sometimes it harms it. But it's what we are. Over ten years we've evolved from a collective of rebel community artists, screenprinting political posters in a union basement, into a multi-discipline design studio that continues to hustle for social change through visual communication.

We work mainly in the community and cultural sectors. Not just because that's where the best work is, but because we figure our environment is already cluttered with sophisticated corporate imagery represent the community's best inte visual messages struggle to be hear din of dominant media. They need to incisively with compelling power and quietly with careful subtlety, just to

Inkahoots has none of the traditiona hierarchy – no art directors, senior/j etc. Although we're Directors in the bu the same hourly rate and working co other full time designers. This is not socialism, but also about respecting of available assets – the creative pro passionate about our work, and the r a broader social context. It doesn't r us to diligently recycle waste paper, for a client who in policy or practice environment. Not that they'd want to

introduction

DESIGNER
Jason Grant, Robyn McDonald, Russel Kerr, and Ben Mangan

DESIGN COMPANY
Inkahoots

COUNTRY OF ORIGIN
Australia

WORK DESCRIPTION
10th anniversary brochure

DIMENSIONS
297 x 210 mm
8 1/2 x 11 3/4 in

anyway. But we graphic designers have noticed a phenomenon (not unique to design) whereby corporations are appropriating alternative visual languages for mainstream audiences. This is deeper than a betrayal of our originality, but is actually a cynical device to manipulate an audience within the sanctity of their own cultural codes.

The kind of work we do might even be a direct parallel to the way we perceive the world. A questioning of accepted ideology may be mirrored in an aesthetic that questions traditional assumptions about layout, legibility and subject matter.

We do what we do because every cultural product that creatively affirms humanity stems the ever-rising tide of corporate & conservative domination. And because...

Robyn McDonald & Jason Grant, Directors

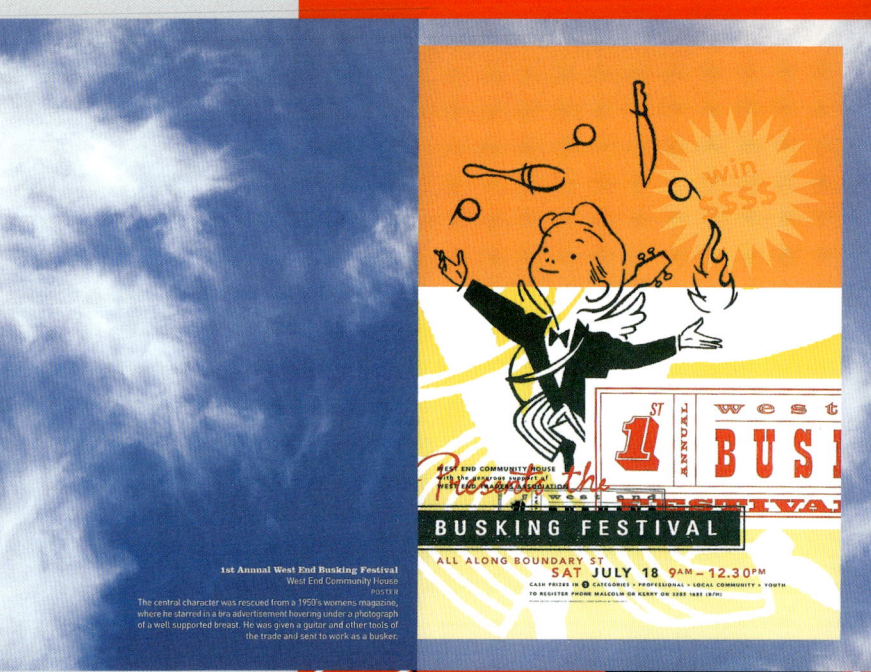

DESIGNER
Jason Grant, Robyn McDonald,
Russel Kerr, and Ben Mangan

DESIGN COMPANY
Inkahoots

COUNTRY OF ORIGIN
Australia

WORK DESCRIPTION
10th anniversary brochure

DIMENSIONS
297 x 210 mm
8 ½ x 11 ¾ in

12

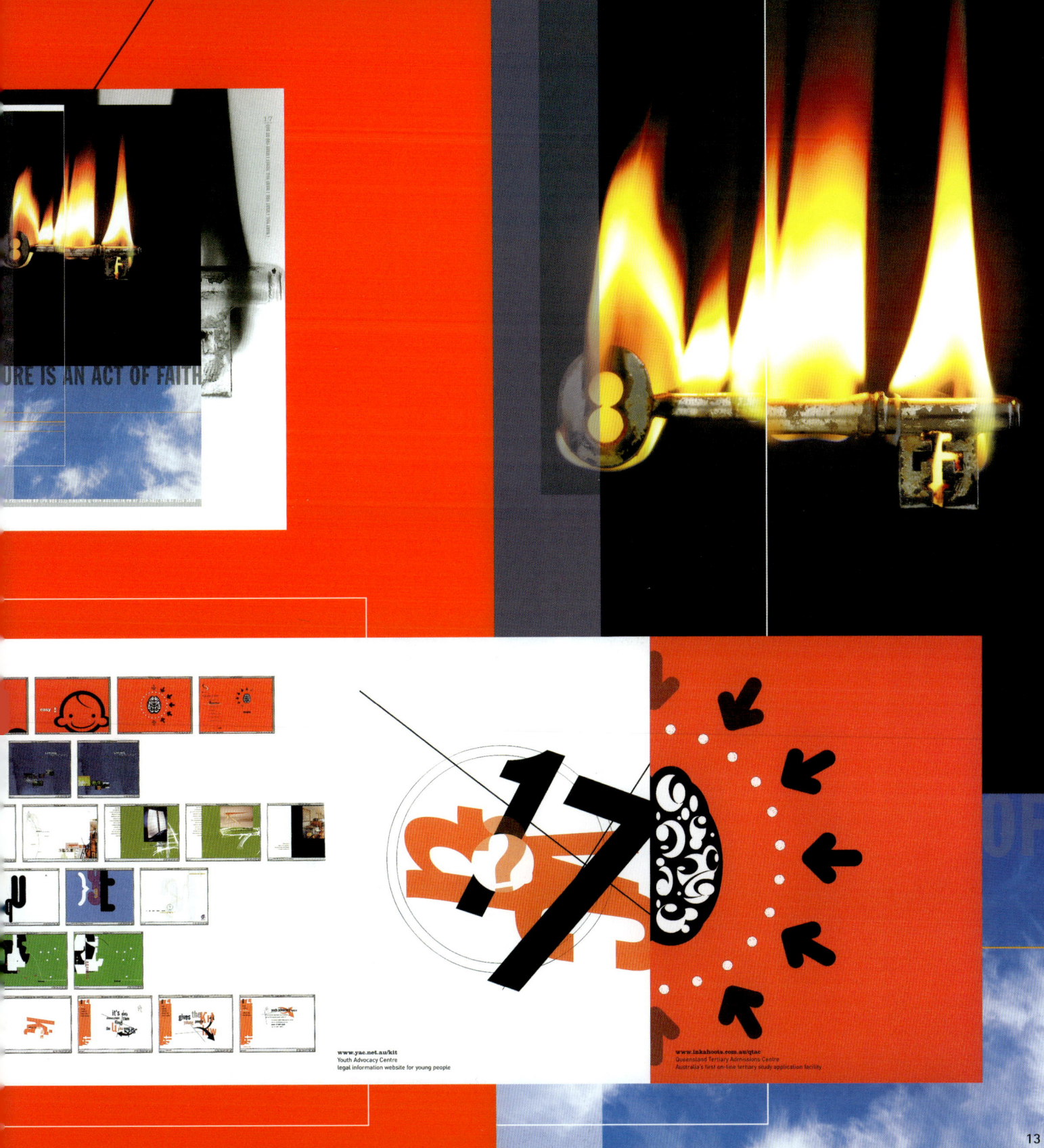

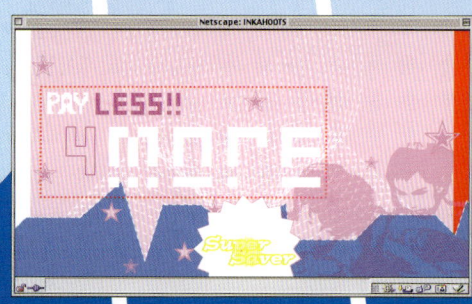
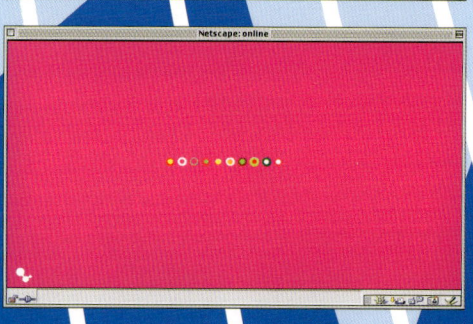
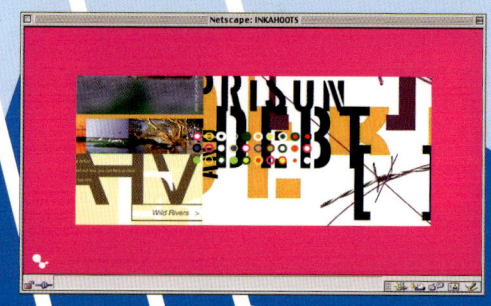

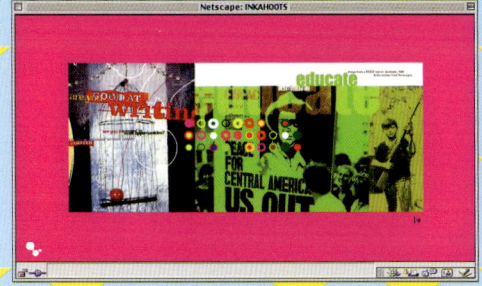 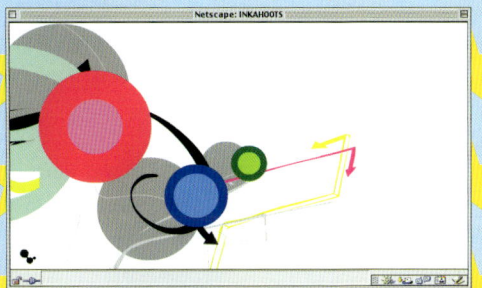 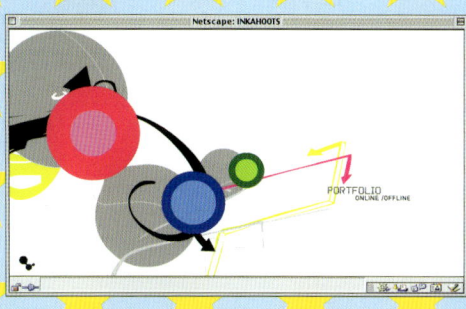
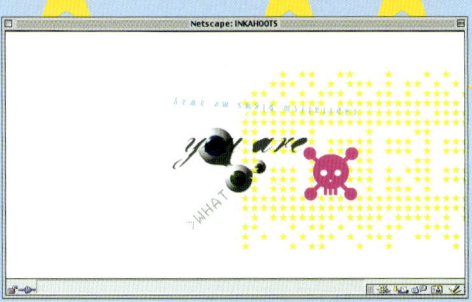 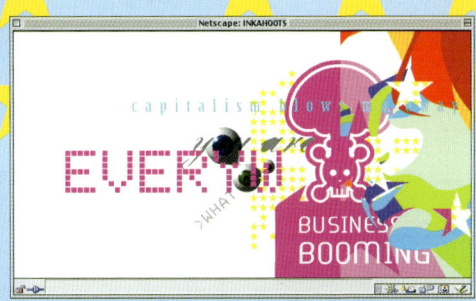 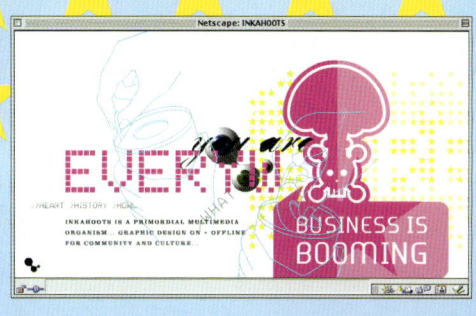
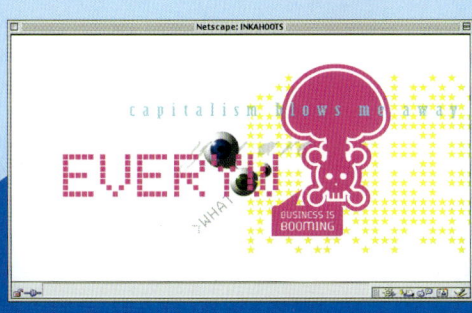

DESIGNER
Jason Grant, Robyn McDonald,
Russel Kerr, and Ben Mangan

DESIGN COMPANY
Inkahoots

COUNTRY OF ORIGIN
Australia

WORK DESCRIPTION
Screen grabs from online showcase

DIMENSIONS
Scalable website

15

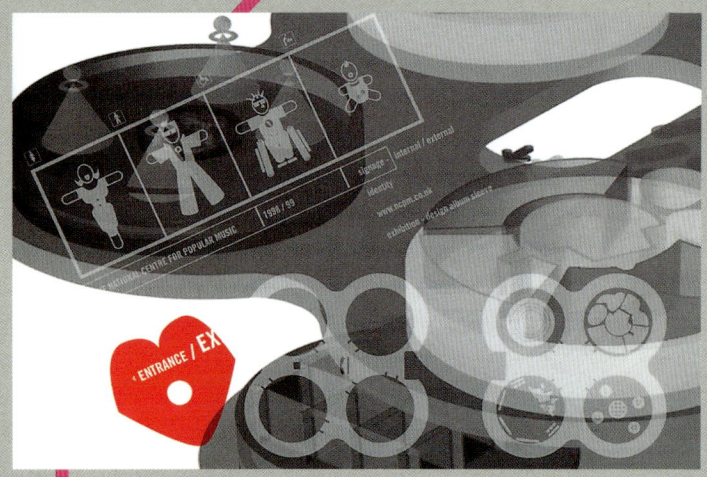

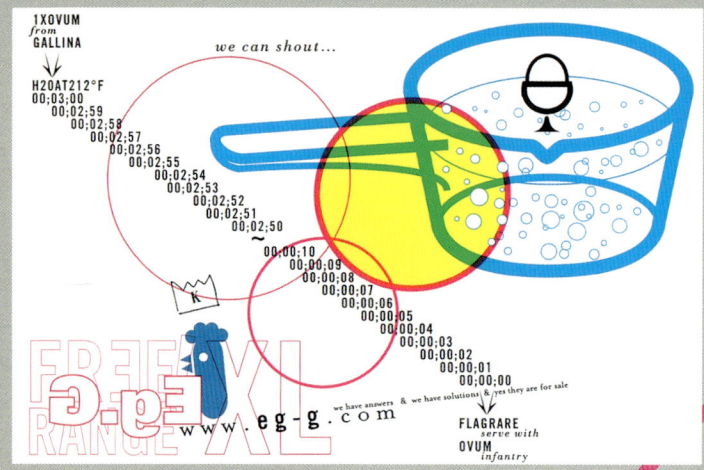

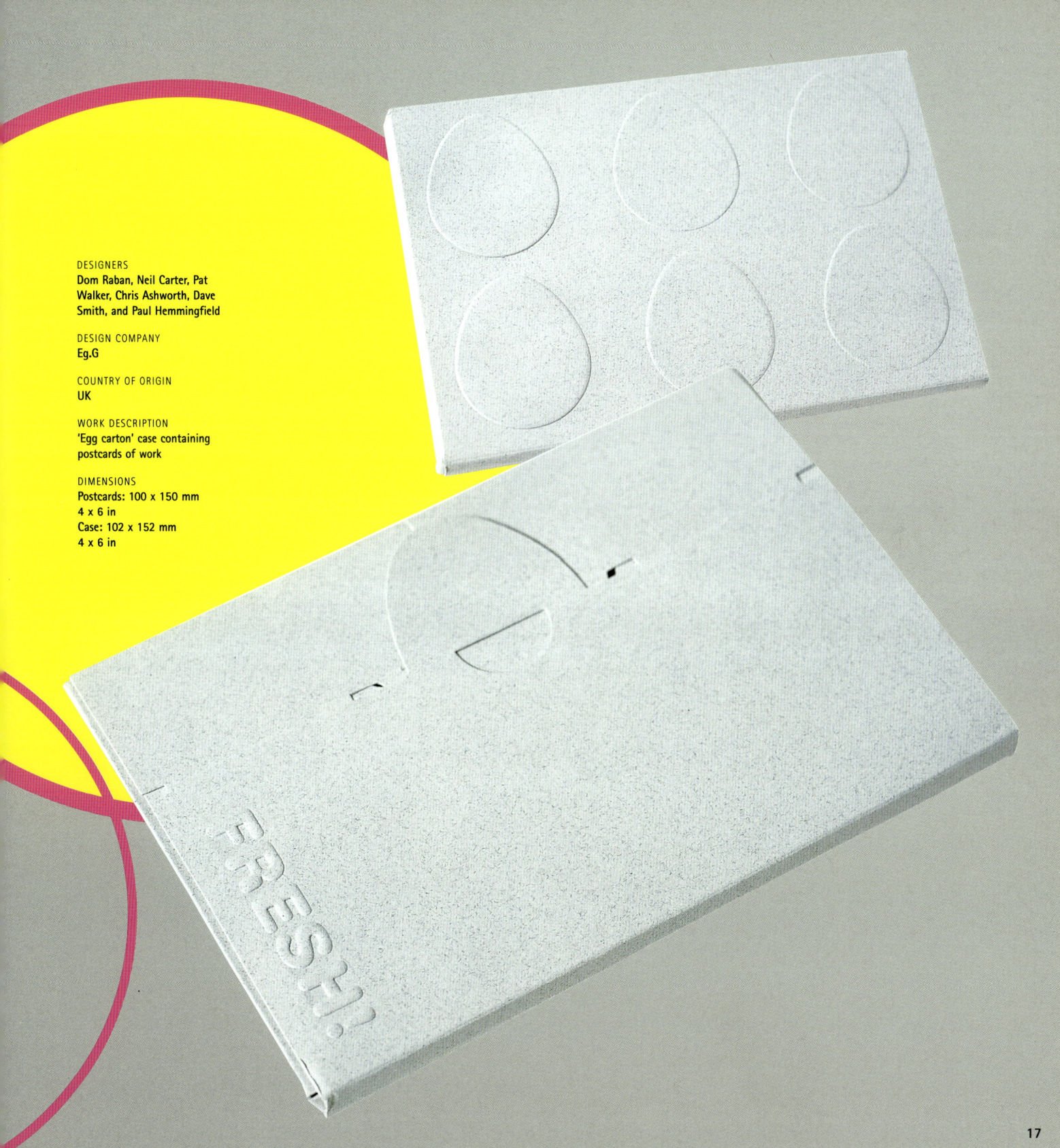

DESIGNERS
Dom Raban, Neil Carter, Pat Walker, Chris Ashworth, Dave Smith, and Paul Hemmingfield

DESIGN COMPANY
Eg.G

COUNTRY OF ORIGIN
UK

WORK DESCRIPTION
'Egg carton' case containing postcards of work

DIMENSIONS
Postcards: 100 x 150 mm
4 x 6 in
Case: 102 x 152 mm
4 x 6 in

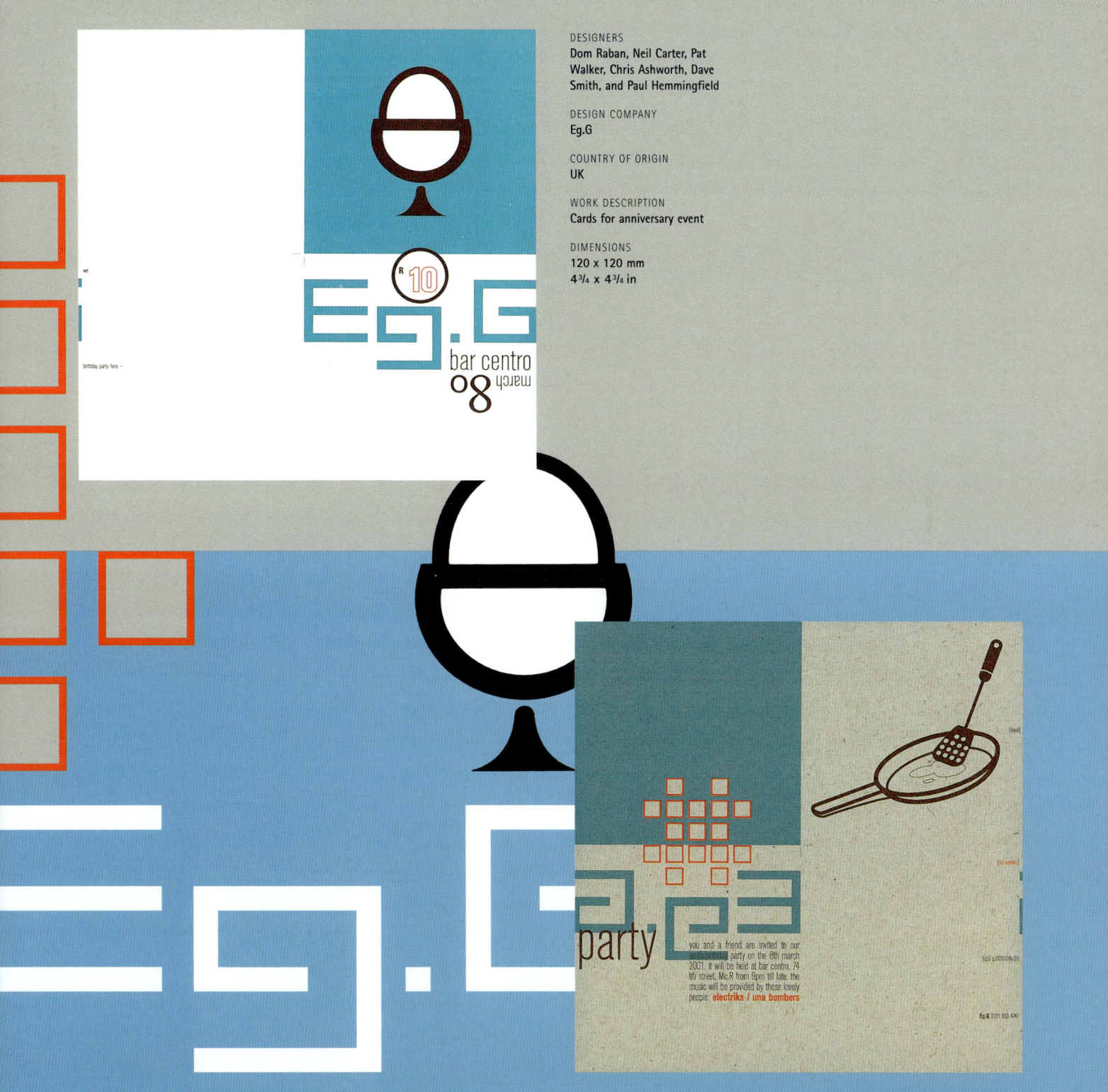

DESIGNERS
Dom Raban, Neil Carter, Pat Walker, Chris Ashworth, Dave Smith, and Paul Hemmingfield

DESIGN COMPANY
Eg.G

COUNTRY OF ORIGIN
UK

WORK DESCRIPTION
Cards for anniversary event

DIMENSIONS
120 x 120 mm
4 3/4 x 4 3/4 in

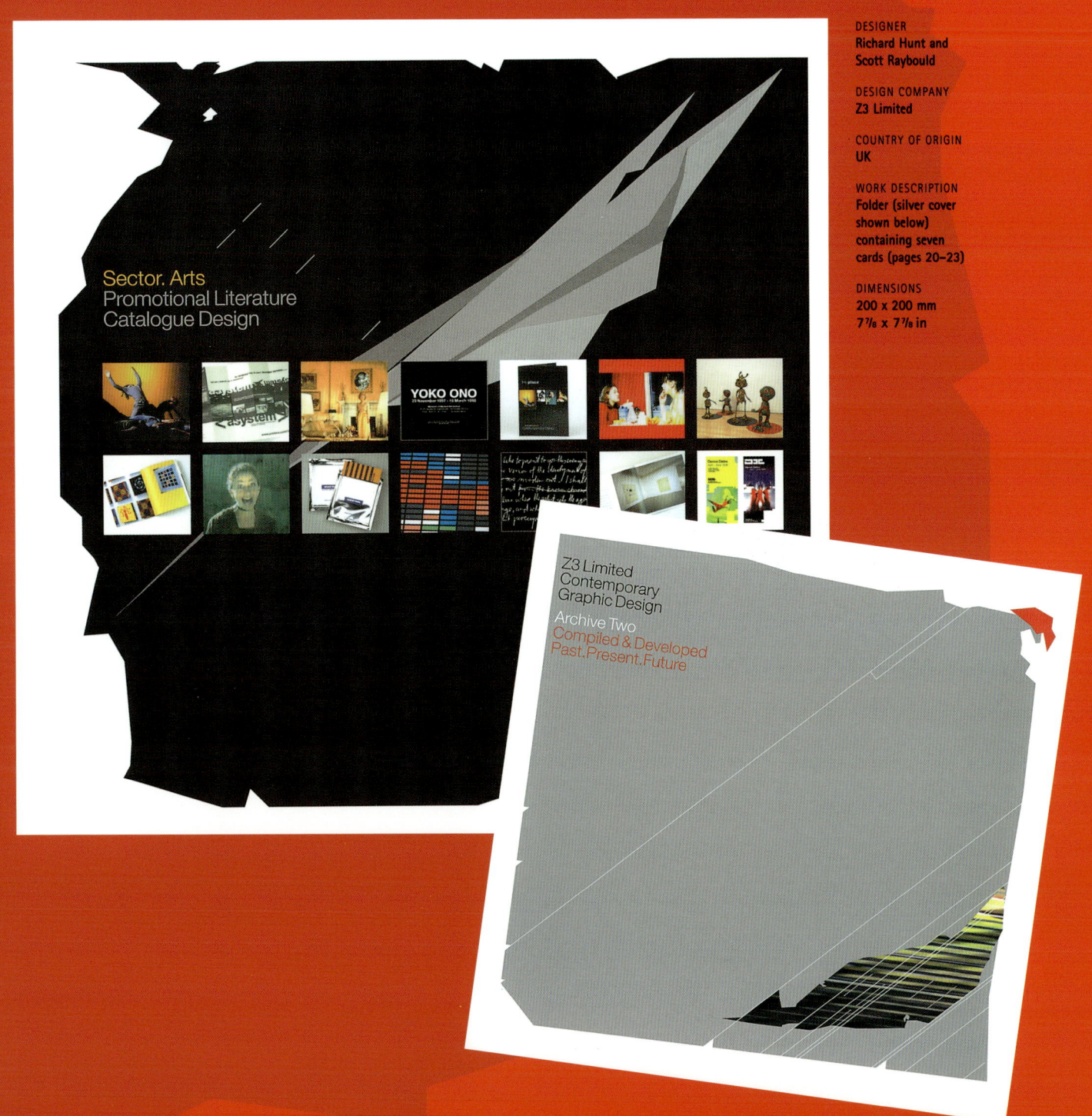

DESIGNER
Richard Hunt and Scott Raybould

DESIGN COMPANY
Z3 Limited

COUNTRY OF ORIGIN
UK

WORK DESCRIPTION
Folder (silver cover shown below) containing seven cards (pages 20–23)

DIMENSIONS
**200 x 200 mm
7 3/8 x 7 3/8 in**

21

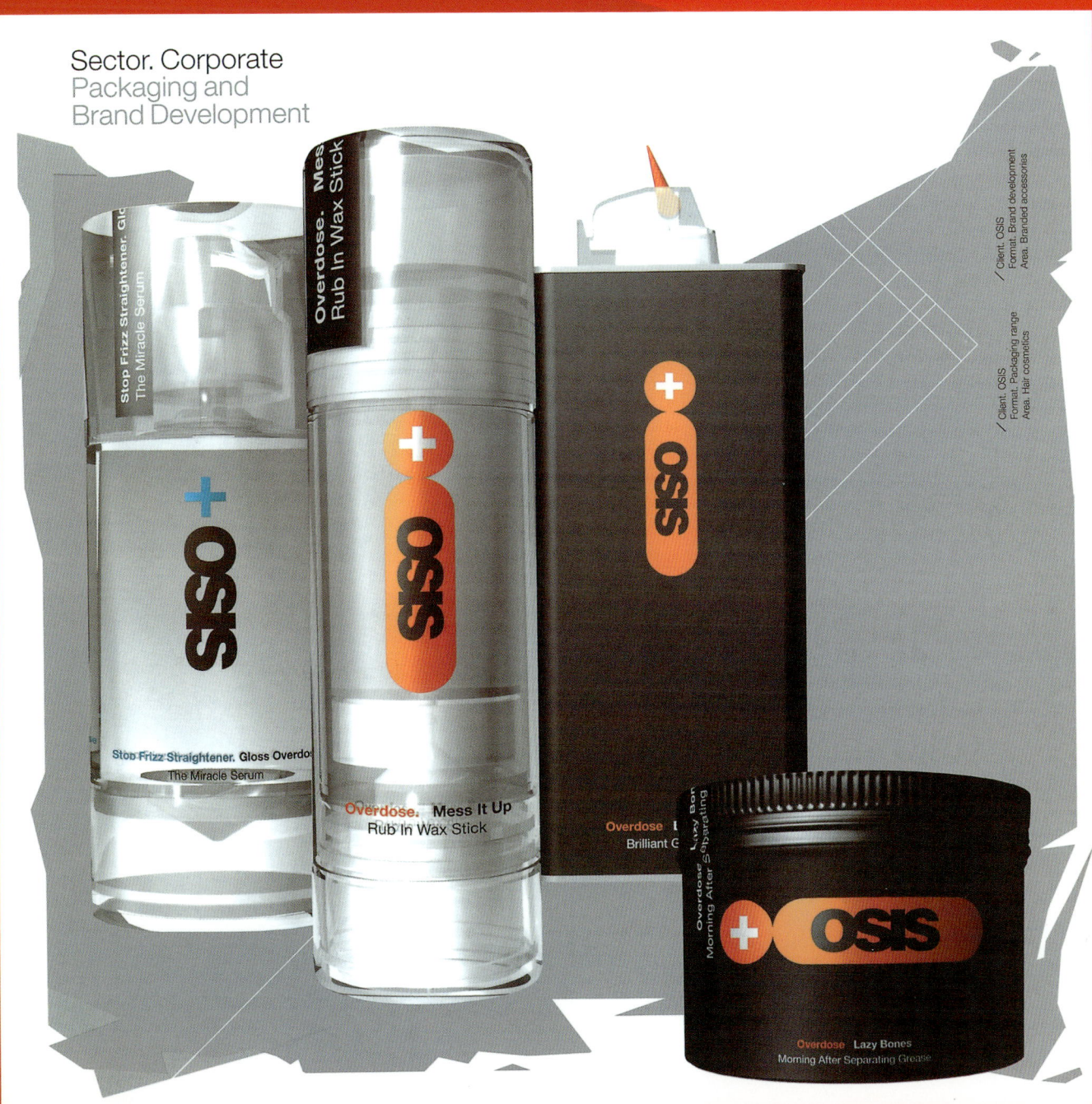

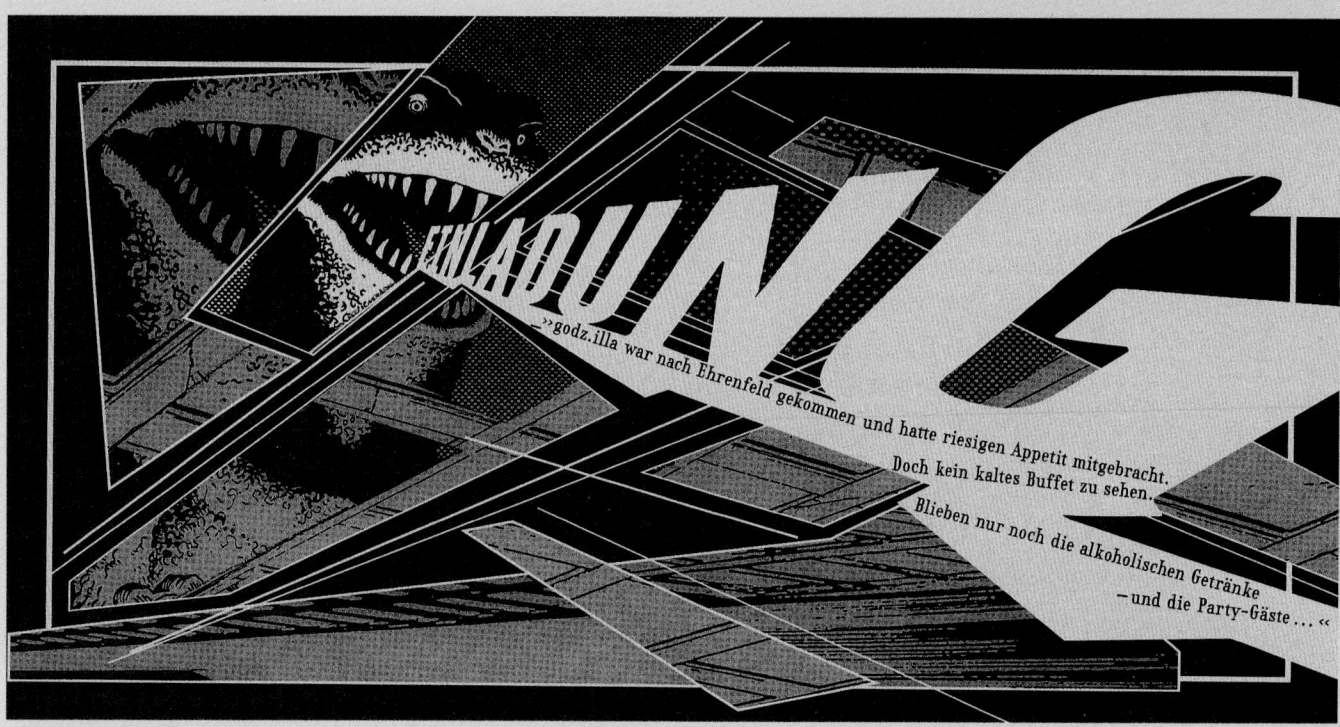

godz

**Deshalb: Erscheinen Sie zahlreich.
Denn am Samstag, den 17. Juni 2000 ab 19.00 Uhr**
weihen wir unsere neuen Räumlichkeiten ein.
Und Sie sind herzlich eingeladen.

Ob Sie alleine oder in Begleitung kommen,
können Sie uns mailen unter: **ja.gerne@godz.de**
Eine Wegbeschreibung finden Sie hier: **www.godz.de**

Wir freuen uns auf Sie...

godz – Agentur für Corporate Advertising
Am Kölner Brett 2 50825 Köln Fon 0221 540 276_0 Fax_80

DESIGNER
Dirk Schumacher and René Tillmann

DESIGN COMPANY
Godz

COUNTRY OF ORIGIN
Germany

WORK DESCRIPTION
Invitation (left) and company brochure (this page)

DIMENSIONS
**Invitation: 235 x 125 mm
9 1/4 x 5 in
Brochure: 220 x 305 mm
8 2/3 x 12 in**

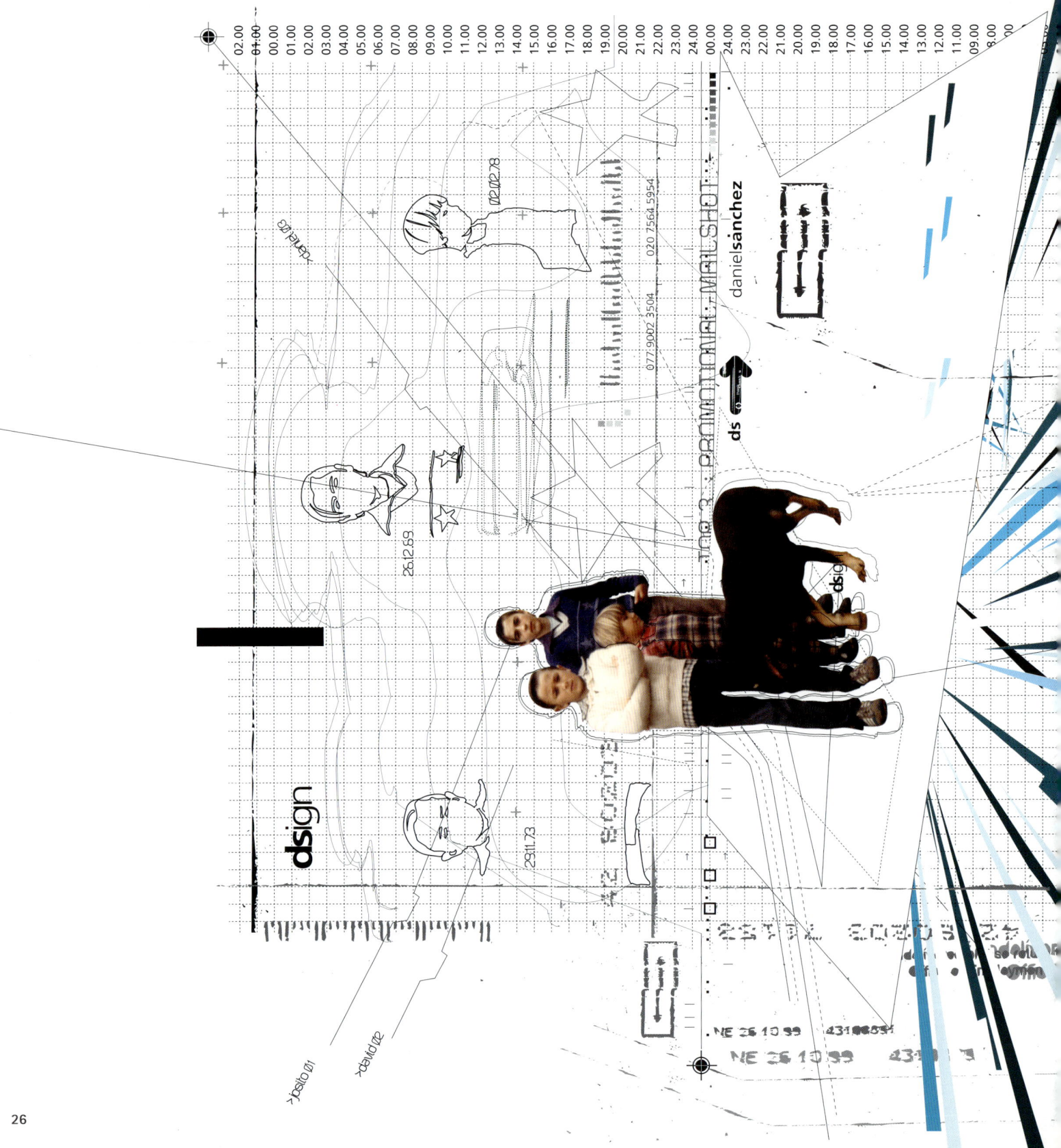

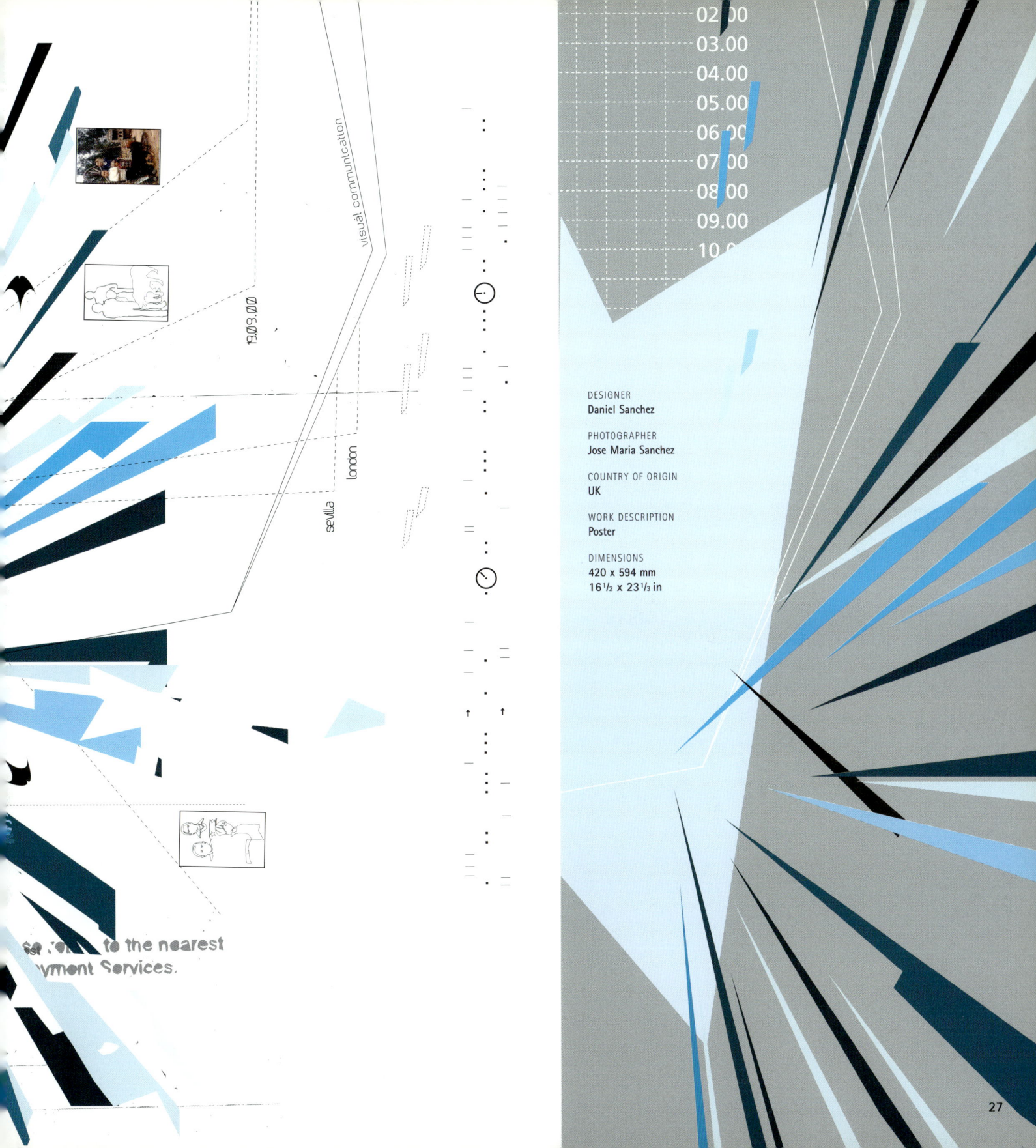

DESIGNER
Daniel Sanchez

PHOTOGRAPHER
Jose Maria Sanchez

COUNTRY OF ORIGIN
UK

WORK DESCRIPTION
Poster

DIMENSIONS
420 x 594 mm
16 1/2 x 23 1/3 in

DESIGNER
Daniel Sanchez

COUNTRY OF ORIGIN
UK

WORK DESCRIPTION
Calendar

DIMENSIONS
**420 x 297 mm
16 1/2 x 11 3/4 in**

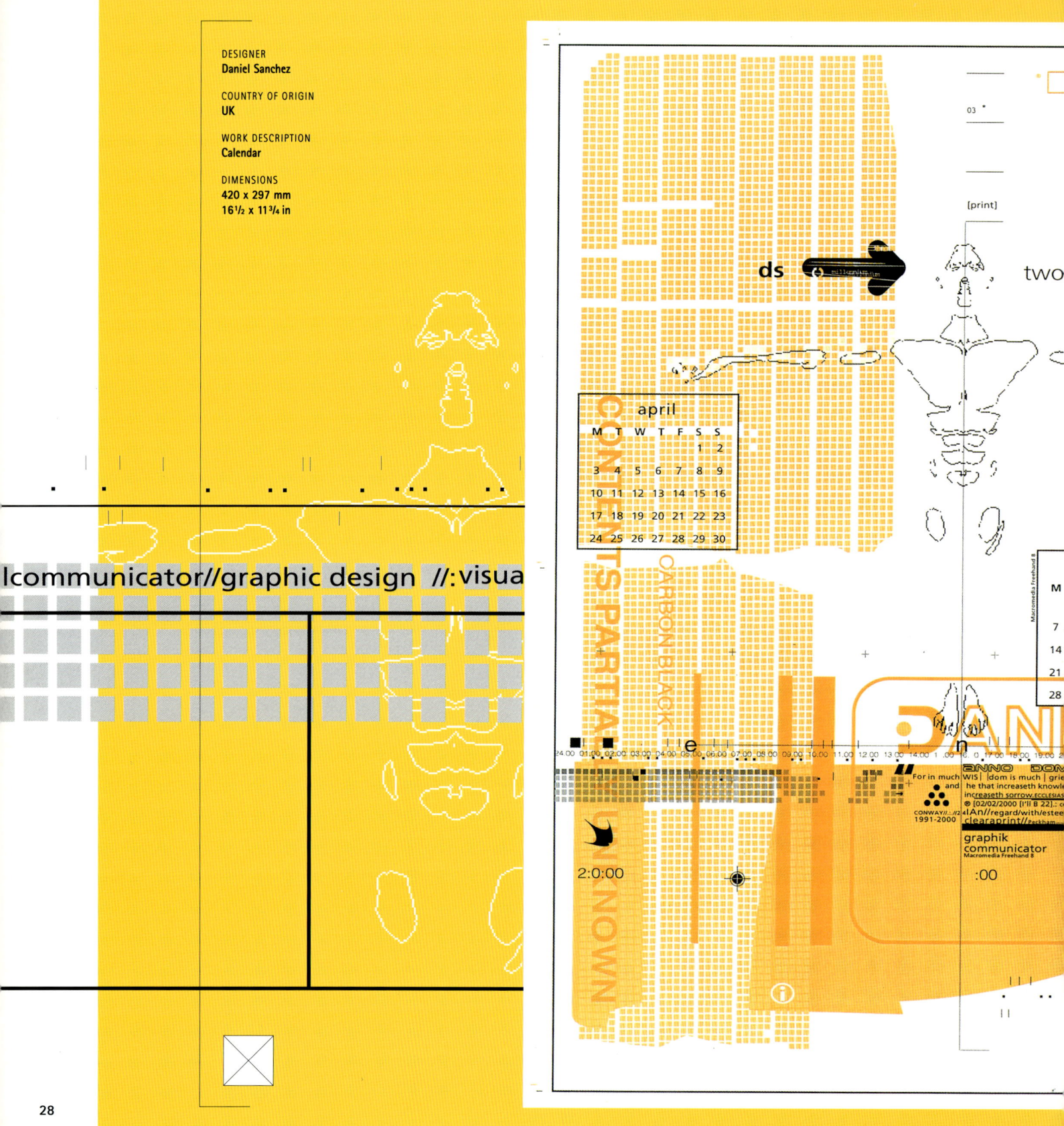

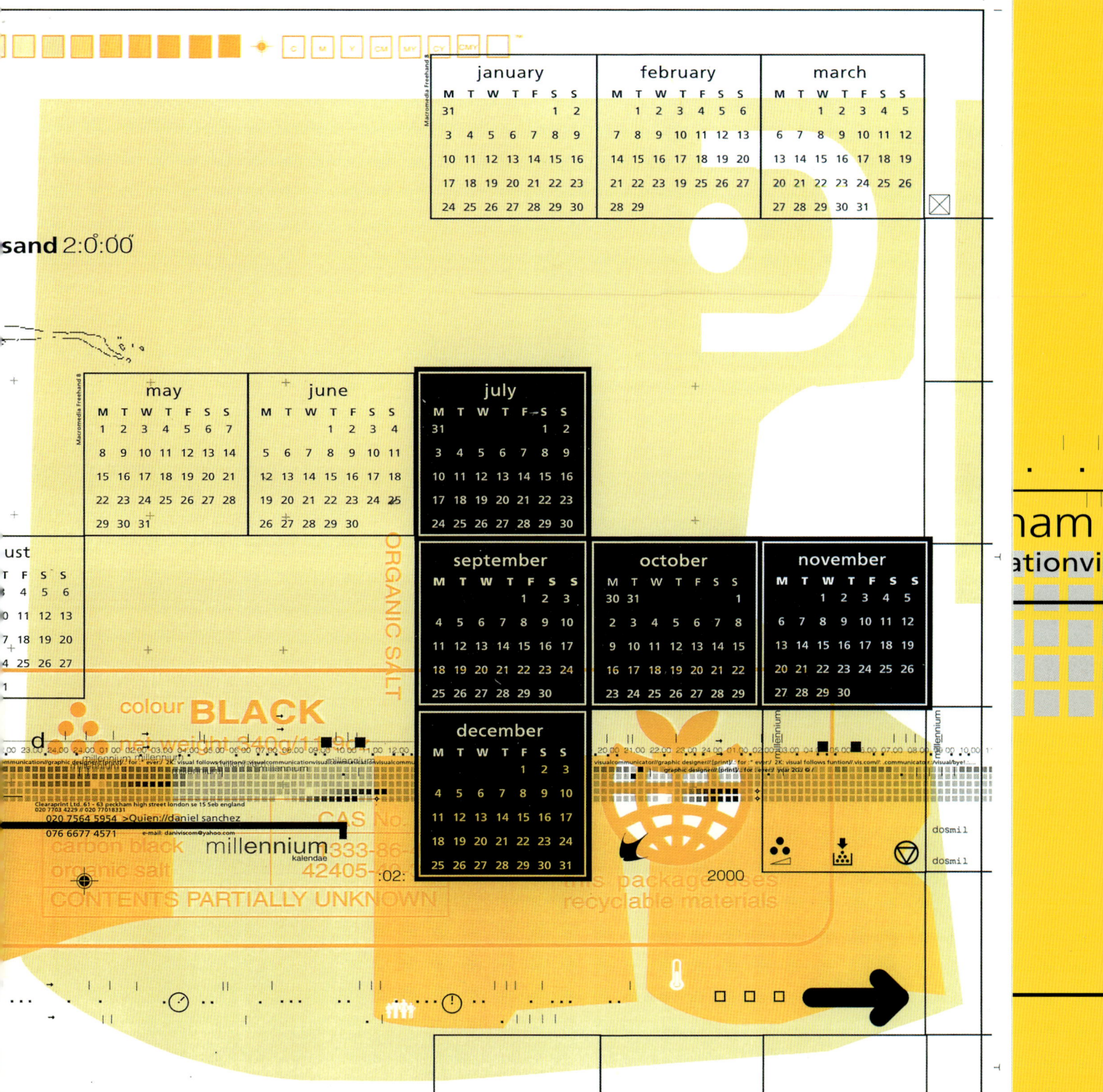

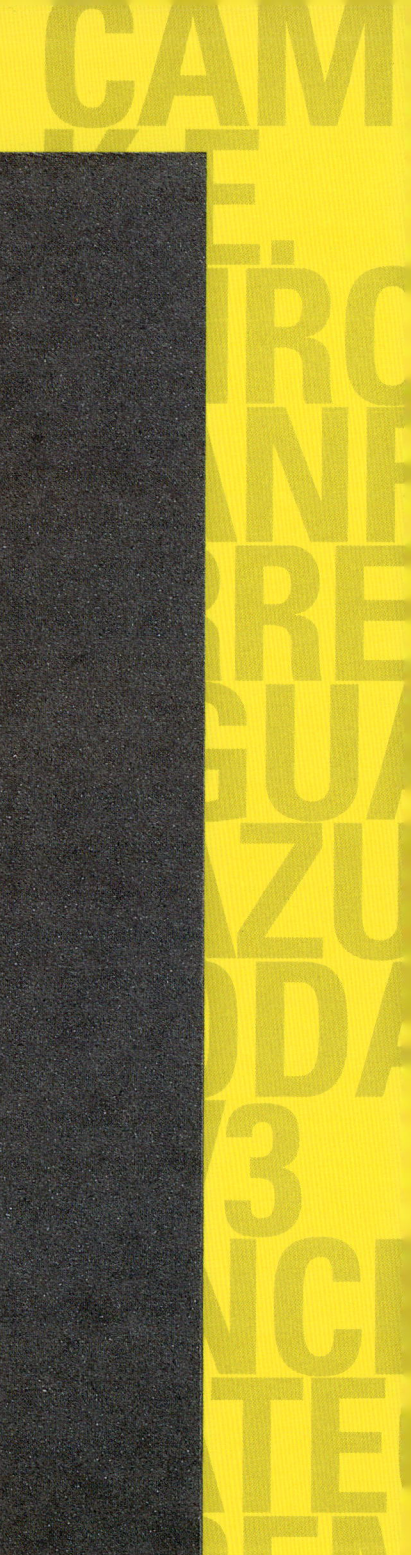

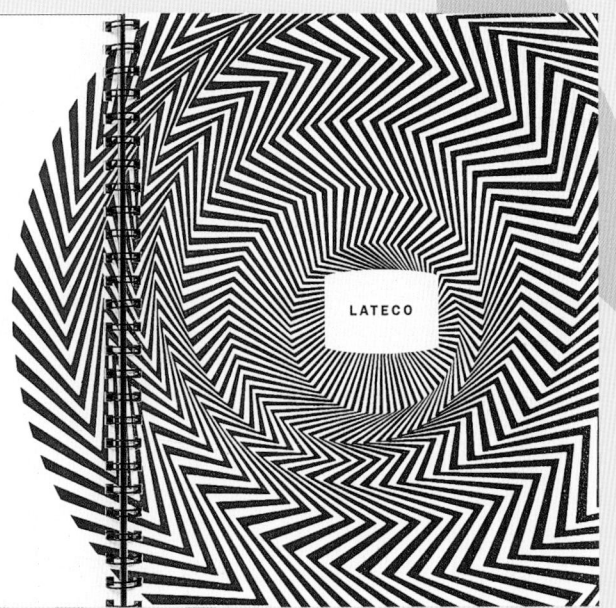

SOLDEU EL TARTER
CAMPER
K.E.
MIRO JEANS
ZANFONIA
ERREGERRE
AGUA
ZAZURCA
RODADOS
TV3
ONCE
LATECO SPOTS
PREMIOS GOYA
REPSOL
CREU ROJA JOVENTUT
PLANETA HUMANO
ENDESA
RETEVISION

PLAY

LATECO

DESIGNER
David Ruiz

DESIGN COMPANY
Ruiz + Company

COUNTRY OF ORIGIN
Spain

WORK DESCRIPTION
Wire bound brochure/book
(opposite and pages 32–33)

DIMENSIONS
268 x 330 mm
10 1/4 x 13 in

31

Look.02 Dossier Zeichenentwicklung Peter Oehjne Design

Welche Fragen sind heute noch relevant?
1/4

DESIGNERS
Heike Auerlich, Eva Feldmann,
Ilka Eiche, and Peter Oehjne

DESIGN COMPANY
Eiche Oehjne Design

COUNTRY OF ORIGIN
Germany

WORK DESCRIPTION
Postcard (far left), newsletter cover
(left), newsletter spread (below)

DIMENSIONS
Postcard: 148 x 105 mm
5 7/8 x 4 1/8 in
Newsletter: 210 x 297 mm
8 1/4 x 11 3/4 in

35

passiert ❙ 1863 fährt die 1. Londoner U-Bahn ❙ 1894 ruft er am 1.1.1863 geborene Pierre de Coubertin die neuzeitlichen Olympischen Spiele ins Leben. 2 Jahre später finden in Athen die 1. Olympischen Spiele statt ❙ 1958 schießen die USA ihren 1. Satelliten „Explorer 1" in den Weltraum ❙ Zwischen dem Deutschen Reich und den Vereinigten Staaten von Amerika findet 1928 der 1. drahtlose Fernsprechverkehr statt ❙ Nach Abschluss der 1. Bundesligasaison wird der 1. FC Köln 1964 mit 6 Punkten Vorsprung Deutscher Fußballmeister ❙ Der 1. Oscar wird 1929 verliehen ❙ 1955 findet in Kassel die 1. Documenta statt ❙ 15.9.1923 – 1. Bauhausausstellung in Weimar ❙ 1801 wird Beethoven taub ❙ 1901 unternimmt Gustav Weißkopf den 1. Motorflug der Geschichte ❙ Die 1. Buchmesse wird in Frankfurt 1949 eröffnet ❙ In Chamonix finden 1924 die 1. Olympischen Winterspiele statt ❙ Das 1. Mal passiert meistens unerwartet ♥ ❙ Die 1. Badeordnung wird 1501 in Baden-Baden erstellt, welche die Erhebung einer aufenthaltsbezogenen Kurtaxe vorsieht ❙ Am 1. Mai 1851 wird die 1. Weltausstellung in London eröffnet ❙ Edgar Wallace wird am 1.4.1875 geboren; mit Stücken wie „Die toten Augen von London" wird er weltbekannt ❙ 1927 macht Charles Lindbergh den 1. Transatlantikflug von New York nach Paris ❙ 1. deutscher Kaiser war Otto 1., der Große ❙ **gesehen** ❙ Mi, 6.9.2000 – 1 Uhr – Segeln – Eurosport ❙ 1960 wird die ARD gegründet – auch das 1. Programm ❙ Goldene ❙ Am 9.9.1928 gibt es die 1. Fernsehvorführung ❙ Der 1. Ritter mit Richard Gere ❙ 1. tragbares TV-Gerät von Grundig – 1957 ❙ 1. Videotext-Ausstrahlung am 26.8.1977 von ARD/ZDF auf der Funkausstellung in Berlin ❙ 1998 im Kino – „Staatsfeind Nr. 1" mit Will Smith und Gene Hackman ❙ 1983 kommt der 1. Camcorder für den Konsumentenbereich heraus ❙ Als 1. deutscher Privatsender strahlt SAT.1 am 1.1.1984 sein Programm bundesweit aus ❙ Am 11.12.1988 startet der Satellit Astra 1A, mit ihm beginnt ein neues Fernsehzeitalter ❙ 1906 legt Arthur Korn den Grundstein für die Bildübertragung durch 1. geglückten Versuch, das Porträt des deutschen Kronprinzen über eine Strecke von 1800 km telegrafisch zu übermitteln ❙ So, 8.10.2000 – Die sieben Männer der Sumuru – 1Uhr – SAT.1 ❙ Auf Seite 1 der Bild am 6.10.2000: Daum zum Drogen Test? – Ein Haar kann seine Unschuld beweisen ❙ **alltäglich** ❙ „1-a-" Schuhreparatur – (04441) 12016 ❙ In der Speisekarte auf Platz Nr 1 – Pizza Margherita ❙ Für Wolle und Feines das Bügeleisen auf Stufe 1 ❙ Für alle, die mit dem Auto davonkommen wollen – der 1. Gang wird gebraucht ❙ 1kg = 1000g ❙ Ein Lächeln auf dem Gesicht, dank der 1 im Zeugnis ❙ Leer und in den Müll? – der traurige Weg der 1-wegflasche ❙ Für 1,29 DM 1 Liter Milch trinken und fit bleiben ❙ Wichtig für jedermann – das 1x1 ❙ 1. Bundesliga – Bayern München wird 1999 wieder Meister ❙ Mit der S1 von Wiesbaden nach Frankfurt Am Glees 1 wegen Oberleitungsstörungen 1 Stunde warten – dafür 1. Klasse fahren ❙ 1000m = 1km ❙ In der Woche vom 9.-15.10 fliegen bei den Schützen der 1. Dekade die Fetzen vor übertriebenem Idealismus ❙ Lebensnotwendig – 1. Hilfe ❙ §1 StVo, Die Teilnahme am Straßenverkehr erfordert ständige Vorsicht und gegenseitige Rücksicht ❙ Mit der XtraCard von T-D1 bekommen Sie günstige Gespräche zu Ihrer Lieblingsnummer, der Xtra Nummer 1 ❙ Immer hilfreich für den Kapitän – der 1. Offizier ❙ Der Traum des kleinen Mannes – das 1-Familien-Haus ❙ **gekauft** ❙ 1 Bällchen Eis für 1,- DM ❙ ISDN-Tipp des Monats: Teledat 150 PCI mit T-ISDN 300 Anschluss 1,- DM ❙ Laugenbrötchen – 1,- DM ❙ Alles für 1,- DM bei Rudi's Resterampe / Gumbertstrasse 145 / Düsseldorf / (0211) 225499 ❙ **informativ** ❙ Das 1. Weltwunder der Kolos von Rhodos ❙ Auf dem 1. östlichen Längengrad – Évreux (Normandie) ❙ Am 4.1.1947 erscheint zum 1. Mal „der Spiegel" ❙ Artikel 1 der Grundrechte: §1 Die Würde des Menschen ist unantastbar. Sie zu achten und zu schützen ist Verpflichtung aller staatlichen Gewalt ❙ Regel 1 für Golfer: Golf spielen ist, einen Ball durch einen Schlag oder aufeinanderfolgende Schläge in Übereinstimmung mit den Regeln vom Abschlag in das Loch zu spielen ❙ 111 km von Baden Baden nach Stuttgart ❙ 1.5. Tag der Arbeit – Maifeiertag ❙ Maßlosigkeit – die 1. Todsünde ❙ 1840 – die 1. Briefmarke der Welt – schwarze One-Penny ❙ Heute für 1,- DM eine Postkarte verschicken ❙ Auf dem 1. Breitengrad nördlich des Äquators – Suvadiva Atoll (Malediven) ❙ Am 29.5.1953 bestiegen Edmund Hillary und Tensing Norgay zum 1. Mal den Mount Everest ❙ Das 1. Endspiel um die Deutsche Fußballmeisterschaft findet am 31.5.1903 statt ❙ Der 1. Alpen-Strassentunnel, Großer Sankt Bernhard, wird am 19.3.1964 das 1. Mal durchfahren. Er verbindet die Schweiz mit Italien ❙ Die 1. öffentliche Bibliothek wird in Rom im Jahre 11 von Gajus Asinius Polio gegründet ❙ 1111km Strassburg – Rom ❙ Die 1. Tour de France startet am 1.7.1903 und der Franzose Maurice Garin gewinnt sie ❙ Führerscheinklasse 1: Krafträder (Zweiräder, auch mit Beiwagen) mit einem Hubraum von mehr als 50 cm³ oder mit einer durch die Bauart bestimmten Höchstgeschwindigkeit von mehr als 50 km/h ❙ Das 1. Gebot: Du sollst keine anderen Götter neben mir haben ❙ Forellen in Ofen auf Grillstufe 1, ca. 20 min ❙ §1 des BGB, Die Rechtsfähigkeit des Menschen beginnt mit der Vollendung der Geburt ❙ Am 6.8.1932 wird die 1. deutsche Autobahn eröffnet. Sie führte von Köln nach Bonn ❙ Sollte sich ein Anlagegut nach Ablauf der Nutzungsdauer noch weiterhin im Betrieb befinden, so ist es mit einem Erinnerungswert von 1,- DM im Anlagekonto auszuweisen ❙ lineare Abschreibung ❙ **zeitlich** ❙ 1.1. Neujahr – Jour de l'an – New Year's Day ❙ Im Jahr 1501 kennen die Inkas eine dezimale Zahlenregistrierung mit Knotenschnüren ❙ Am 6.6.1920 findet die 1. Reichstagswahl statt ❙ 1601 wird die Schallgeschwindigkeit von Bacon gemessen ❙ Die 1. UN-Generalversammlung tritt am 10.1.1949 zusammen ❙ Am 11.2.1919 wird Friedrich Ebert 1. deutscher Reichspräsident ❙ 1501 findet die Buchdruckerkunst des Johannes Gutenberg sehr rasche Verbreitung ❙ George Washington wird am 30.4.1789 1. US-Präsident ❙ Die 1. Verleihung der Nobelpreise geht 1901 an Konrad Röntgen, Adolph von Behring, Henri Dunant und Frederic Passy ❙ 1301 wird Dante Alighieri aus Florenz vertrieben und in Abwesenheit zum Tode verurteilt ❙ Frauen dürfen am 19.1.1919 das 1. Mal wählen ❙ Im Jahr 1 wandern die Goten nach Südrußland bis zum Schwarzen Meer ❙ 3.12.2000 – 1. Advent ❙ 1201 entsteht im Donaugebiet das Nibelungenlied ❙ Januar bis März – 1. Quartal ❙ 1. Bundeskanzler der Bundesrepublik, wird am 15.9.1949 Konrad Adenauer ❙ **gezählt** ❙ 11100110 – maschinensprachliche Algorithmen sind schwer lesbar, unübersichtlich und mit hohem Erstellungsaufwand verbunden ❙ 1x1 = 1 ❙ 27.11.2000 – 1,- DM = 0.42 $ ❙ 1" = 1 ❙ 1,- DM = 3,40 guatemaltekischer Quezel ❙ 1/1 = 1 ❙ Für ca. 1,25 $ hätte man am 6.12.1996 1 Euro bekommen, bis jetzt hat er rund 30% seines Wertes verloren. 9.10.2000 – 1 Euro = 0,8695 $ ❙ Mit 5 Weizen und 3 Doppelkorn hat ein Mann mit 90 kg auch noch 2 Stunden noch 1 Promille ❙ Ab 1.1.2002 haben wir den Euro im Portemonnaie ❙ **bewegt** ❙ 22.4.1915 – 1. deutscher Giftgasangriff ❙ 1. Weltkrieg – 1914 bis 1918 – 12 Mio. Tote ❙ Am 14.12.1911 trifft Roald Amundsen als 1. Mensch am Südpol ein ❙ Auf Hiroshima wurde am 6.8.1945 die 1. Atombombe abgeworfen, die 260.000 Todesopfer forderte ❙ 1. Liebe ❙ 6.9.2000 – Michael Schumacher wird in Japan Formel-1 Weltmeister ❙ 1. Toter an der Berliner Mauer ist der Ostberliner Bauarbeiter Peter Fechter, der beim Versuch am 17.8.62 über die Mauer in den Westteil der Stadt zu flüchten von DDR-Grenzsoldaten niedergeschossen wurde ❙ Annemarie Regner wird 1972 die 1. Bundestagspräsidentin ❙ 1. Zahn ❙ Am 21.7.1969 setzte Neil Armstrong als 1. seinen Fuß auf den Mond ❙ Leichtathletik Weltrekord über 1 Meile – Hicham El Guerrouj (MAR) – 3:43,13 – 1999 ❙ Am 18.8.1949 findet die 1. Wahl zum Bundestag statt – CDU wird stärkste Fraktion ❙ 1987 wird Steffi Graf Nr. 1 – ein Jahr später feiert sie ihren 1. Wimbledon Sieg ❙ In Hessen gibt es 1985 die 1. rot-grüne Koalition ❙ Der 1. Mensch im Weltall ist der sowjetische Kosmonaut Juri Alexejewitsch Gagarin (12.4.1961) ❙ 1. Schritte ❙ 1. Gold für Deutschland bei Sydney 2000 holt der Bahnsprinter Robert Bartko ❙ **entwickelt** ❙ Das 1. Kernkraftwerk entsteht am 17.6.1961 ❙ 1844 übermittelt der US-amerikanische Erfinder Samuel Morse auf einer Versuchsleitung von Washington nach Baltimore das 1. Morsetelegramm ❙ 1796 – 1. Pockenschutzimpfung ❙ Im Middletown in Großbritannien fährt 1812 die 1. Zahnradbahn der Welt ❙ 1964 stellt die Lufthansa in München ihre 1. Boeing 727 vor ❙ Die 1. Herztransplantation wird am 3.12.1967 durchgeführt ❙ 1901 werden der Staubsauger, die 1. elektrische Schreibmaschine und der Rasierapparat erfunden ❙ 1701 fertigt der englische Astronom Edmond Halley die 1. Weltkarte der magnetischen Deklination an ❙ Am 1.11.1952 bringen die USA auf dem zu den Marshallinseln gehörenden Enwetok-Atoll im Zentralpazifik die 1. Wasserstoffbombe der Menschheitsgeschichte zur Explosion ❙ 1. drahtlose Infrarot-Fernbedienung für Fernsehempfänger – 1962, mit ihr gewinnt der Zuschauer wieder Macht zurück (zappen) ❙ 1854 lässt Heinrich Göbel die 1. Glühbirne leuchten ❙ Am 2. März 1969 startet das Überschallflugzeug Concorde zum 1. Mal ❙ Martin Behaim schuf 1492 den 1. Globus ❙ **gehört** ❙ Am 18.8.1933 wird der 1. Volksempfänger angeschaltet ❙ Britney Spears im September lange auf Platz 1 – ihre 1. Platinauszeichnung bekommt sie mit 19 Jahren ❙ In Berlin eröffnet am 4.12.1924 die 1. Funkausstellung ❙ Hit der Beatles – „Please Please me" ❙ Beim Smalltalk Nr. 1 – das Wetter ❙ hr3 / 10.10.2000 / 11 Uhr A3 Frankfurt-Köln / Frankfurter Kreuz Richtung Kelsterbach / 1-spurige Verkehrsführung / mehrere km stockender Verkehr ❙ 1965 beginnt die 1. Produktion von Musik-Cassetten ❙ Die 1. Geige ❙ Im Sommer 1979 wird in Japan der 1. Walkman eingeführt ❙ Das Bergsteigwetter im Schwarzwald am 10.10.2000 – Vogesen – nachts um 1" ❙ Die 1. deutsche Oper „Daphne" von Heinrich Schütz wird 1594 in Torgau uraufgeführt ❙ 1958 wurden die 1. Grammys verliehen ❙

gewünscht ❙ Für das Jahr 2001 wünschen wir Ihnen alles Gute. Peter Oehjne Design

www.oehjne-design.de

36

Peter Oehjne Design In eigener Sache Adressenänderung

▶ Unser Start ins neue Jahrtausend beginnt mit einem Wechsel unseres Agentursitzes in Frankfurt. Ab Mai eröffnen wir unsere neuen Büroräume.

Information Peter Oehjne Design Change of Address

Location — Westerbachstraße 287, 65936 Frankfurt am Main, Germany — Telefon +(0)69. 34 82 62 07 / Telefax +(0)69. 34 82 62 07

Picture — Leaf of a chestnut-tree, found outside the house at the old address — On the 15th of June 1998, date of removal

DESIGNER
Heike Auerlich, Eva Feldmann, Ilka Eiche, and Peter Oehjne

DESIGN COMPANY
Eiche Ohejne Design

COUNTRY OF ORIGIN
Germany

WORK DESCRIPTION
Poster (far left) and postcards announcing change of address

DIMENSIONS
Poster: 594 x 840 mm
23 1/3 x 33 1/8 in
Postcards: 210 x 99 mm
8 1/4 x 8 7/8 in

ÜBER 130 JAHRE FAMILIENUNTERNEHMEN

BESTATTUNGSHAUS HERWEG

Inhaber Hans Herweg

Es bedarf der Erfahrung, eine zeitgemäße, würdige Form der Bestattung zu finden und zu erfüllen.

Wir können Sie in einem Trauerfall sachkundig beraten und übernehmen für Sie die Erledigung aller unerläßlichen Formalitäten.

Dellbrücker Hauptstraße 152
51069 Köln - Dellbruck
Telefon 0221 / 9684540
Telefax 0221 / 6804951

Die Zukunft ist als Raum der Möglichkeiten der Raum unserer Freiheit.

DESIGNER
Heike Auerlich, Eva Feldmann,
Ilka Eiche, and Peter Oehjne

DESIGN COMPANY
Eiche Ohejne Design

COUNTRY OF ORIGIN
Germany

WORK DESCRIPTION
Poster

DIMENSIONS
594 x 840 mm
23 1/3 x 33 1/8 in

DESIGNER
Christie Rixford and Hajdeja Ehline

DESIGN COMPANY
Super Natural Design

COUNTRY OF ORIGIN
USA

WORK DESCRIPTION
Envelope (above) containing diecut introductory booklet

DIMENSIONS
**Booklet: 128 x 192 mm
5 x 7 1/2 in
Envelope: 206 x 140 mm
8 1/8 x 5 1/2 in**

40

motion graphics

demo reel

super_natural_design

cd>lp packaging

ubiquity recordings

41

DESIGNERS
Niall Jerveys and Shahrokh Nael

DESIGN COMPANY
The Design Unit (tDu)

COUNTRY OF ORIGIN
UK

WORK DESCRIPTION
Promotional website

DIMENSIONS
Website

Staff ID

Shahrokh Na'el
WEB CO-ORDINATOR
snael@ccm.ac.uk

Contact

beep

GALLERY

- BUSINESSES
- EDUCATION
- WEBSITES
- MARKETING

HOME

43

gallery

pick your favourite
picture from the samples
of work

DESIGNERS
Niall Jerveys and
Paul Cunningham

DESIGN COMPANY
The Design Unit (tDu)

COUNTRY OF ORIGIN
UK

WORK DESCRIPTION
Promotional brochure. Double page spreads (top left and top right); gatefold pullout section (right); front and back covers (page 46, top); further double page spreads (pages 46–47)

DIMENSIONS
80 x 80 mm
3 1/8 x 3 1/8 in

The Design Unit,
City College Manchester,
Wythenshawe Centre, Moor Road,
Wythenshawe, Manchester, M23 9BQ
T: 0161 957 1516 F: 0161 957 1501

SPOT THE LOGO

W

www.citycol.com/tdu

who
WE ARE

We are an established in-house
design unit operating within
City College Manchester.
We operate state-of-the-art machinery
to produce quality solutions to your
creative communication needs.

Visit our website to see the wide
variety of work that we do.

WHAT OTHER PEOPLE
say

Innovative, fresh & funky ideas,
quick pressure turn-around, sourcing great
materials for printing and
reasonably priced.

PHIL ELLIS, RAW FISH RECORDS

We have had many positive comments on the layout,
text and quality of booklet both from parents and
professionals.

FIONA WORRALL, HIGH SCOPE STRATEGY GROUP

...a dynamic company image sells tickets and for a
full house you can rely on the design unit to get it
spot on.

CAROLINE CLEGG, FEELGOOD THEATRE PRODUCTIONS

We found the design innovative. Also we were
impressed with the ability to set and keep to
deadlines which were often quite tight.

DAVE CRONIN, THE INTERNATIONAL OFFICE

tdu@ccm.ac.uk

vidal loesener

eG

Vidale-Gloesener Graphic Design

13, rue du Marché-aux-Herbes
L-1728 Luxembourg
Grand Duchy of Luxembourg
Telephone (352) 26 20 15 20
Fax (352) 26 20 15 21

E-mail vidalegloesener@pt.lu

design!

vidalegloesener

13, rue du Marché-aux-Herbes L-1728 Luxembourg
Telephone (352) 26 20 15 20 Fax (352) 26 20 15 21

DESIGNER
Silvano Vidale and
Tom Gloesener

DESIGN COMPANY
Vidale Gloesener

COUNTRY OF ORIGIN
Luxembourg

WORK DESCRIPTION
Easter card and corporate
advertisement

DIMENSIONS
Card: 100 x 210 mm
4 x 8 1/4 in
Corporate ad: 105 x 148 mm
4 1/8 x 5 7/8 in

A-109

6H
< 404
GH
graphic havoc ava: transforming looking into seeing
INFORMATION ARCHITECTURE

DESIGNER
Graphic Havoc avisualagency

DESIGN COMPANY
Graphic Havoc avisualagency

COUNTRY OF ORIGIN
USA

WORK DESCRIPTION
Flyer

DIMENSIONS
**279 x 215 mm
11 x 8 1/2 in**

DESIGNER
Graphic Havoc avisualagency

DESIGN COMPANY
Graphic Havoc avisualagency

COUNTRY OF ORIGIN
USA

WORK DESCRIPTION
Cards and stickers

DIMENSIONS
Various

LOCK

SIDES

OSE AND LOCK
OORS BOTH SIDES
EFORE MOVING

TRANSITION

Form

DESIGNERS
Paul West, Paula Benson,
John Siddle, and Chris Hilton

DESIGN COMPANY
Form

COUNTRY OF ORIGIN
UK

WORK DESCRIPTION
Diecut metal ring binder
with inserts

DIMENSIONS
173 x 226 mm
6 3/4 x 8 7/8 in

DESIGNERS
Paul West, Paula Benson,
John Siddle, and Chris Hilton

DESIGN COMPANY
Form

COUNTRY OF ORIGIN
UK

WORK DESCRIPTION
Website

DIMENSIONS
Website

57

DESIGNER
Form

DESIGN COMPANY
Uniform

COUNTRY OF ORIGIN
UK

WORK DESCRIPTION
Website

DIMENSIONS
Website

DESIGNER
Walter Stähli

DESIGN COMPANY
Extense

COUNTRY OF ORIGIN
Switzerland

WORK DESCRIPTION
Booklet to promote new website
(shown as double page spreads)

DIMENSIONS
Folded size: 105 x 148 mm
4 1/8 x 5 7/8 in

PRERELEASE BOOKLET
MYKROT.COM 2001 BY WALTER STÄHLI

2001 GRAPHIC DESIGN MUSIC PHOTOGRAPHY INTERIORS IMPRESSUM HOME

EXTENSE

EXTENSE IS A MEETING PLACE
FOR PEOPLE WHO WORK IN THE
ARTS AND/OR IN SCIENCE.

FLASHED SITE. GET THE PLUG IN AT
MACROMEDIA.COM

VS. 1 / 3 2001

61

2001 ■ MUSIC HOME

CM PROMO CD IN 3 PARTS ▼ CALCULATED MUSIC

ik
FRAKTALE MUSIK
CHRISTOPH MÜHLETALER

1	WE'VE	SEEN	ALL	THIS
2	SOME	DAY		
3	THE	NATIONAL	CIRCUS	

CM PROMO CD IN 3 PARTS
01/2001 CALCULATED MUSIC

extense

CM PROMO CD

nora

2001 ■ LITERATURE

müde A COLLECTION OF SHORT STORIES

Marcel glaubte, es sei ein S
sie einander hinterher schr
wirklich war.

Priska hatte die Fernbedien
Fenster gelaufen. Marcel hä
Himmel zerrissen.

Er kroch vom kalten Stein des Kachelofens heru
hastig die Stiefel an...

62

DESIGNER
Walter Stähli

DESIGN COMPANY
Extense

COUNTRY OF ORIGIN
Switzerland

WORK DESCRIPTION
Booklet to promote new website (shown as double page spreads)

DIMENSIONS
**Folded size: 105 x 148 mm
4 1/8 x 5 7/8 in**

IN THE PLACE OF COINCIDENCE

PARIS
BONN
LINZ
BIENNE
ROME
BUY ME
SEATTLE
URBINO
BUFFALO
MUNICH
A NOFRONTIERE PUBLICATION
VIENNA

DESIGNER
Nofrontiere Design

DESIGN COMPANY
Nofrontiere Design

COUNTRY OF ORIGIN
Austria

WORK DESCRIPTION
Promotional book

DIMENSIONS
**242 x 298 mm
9 1/2 x 11 3/4 in**

DESIGNER
Nofrontiere Design

DESIGN COMPANY
Nofrontiere Design

COUNTRY OF ORIGIN
Austria

WORK DESCRIPTION
Promotional book

DIMENSIONS
**242 x 298 mm
9 1/2 x 11 3/4 in**

> ANDREAS
Project Manager IT

> WOLFGANG
Programmer

> STEPHAN
Programmer

> ULF
Art Director

> ELISABETH
Designer

> GESCHE
Designer

> MARKUS
Managing Director
New Business, Sales & Marketing

54/55

DESIGNER
Pentagram

DESIGN COMPANY
Pentagram

COUNTRY OF ORIGIN
UK/USA

WORK DESCRIPTION
Books of collected work

DIMENSIONS
**107 x 148 mm
4¼ x 5⅞ in**

70

Tate Gallery
The London art gallery

Published primarily in the 1880s, souvenir albums brought the wonders of the world to people who often had never ventured more than 50 miles from home. Through the marvel [of printing, one could] tour the newly built Statue [of Liberty on a sheet of] paper. They could see N[iagara Falls, visit Civil] War battlegrounds, distant [lands and places that] may have only been describ[ed to them. Costing from] 25 cents to $1.50, these [albums provided a sense] of documentary reality una[vailable elsewhere.]

Like souvenir [albums, the processes that] gave rise to them survived [only a short period of time] – quickly disappearing after 1895 with the introduction of photomechanical processes that allowed photographs to be reproduced directly instead of being redrawn.

For the most part, lithographic miniatures were printed on one side on a single long sheet of paper, then folded accordion-style, and pasted onto the inside front of a [cardboard co]ver. To mimic the tonality of [photographs,] [the images were printed in] [sepia ink. Most books included cap]tions in two or three languages.

A predecessor to today's travel postcards, souvenir albums had a much greater impact on the public at large, exposing them to sights that they had only tried to imagine.

DESIGNER
Pentagram

DESIGN COMPANY
Pentagram

COUNTRY OF ORIGIN
UK/USA

WORK DESCRIPTION
'Pentagram Papers' book with gatefold (left); two 'Christmas Books,' covers, and double spreads (left)

DIMENSIONS
Various

"A retentive memory may be a good thing but the ability to forget is the true token of greatness."

Men
Very
Easily
Make
Jugs
Serve
Useful
Nocturnal
Purposes

DESIGNER
Pentagram

DESIGN COMPANY
Pentagram

COUNTRY OF ORIGIN
UK/USA

WORK DESCRIPTION
'Pentagram Five' book

DIMENSIONS
**200 x 275 mm
7⅞ x 10⅞ in**

aesent luptatum

DESIGNER
Alvin Tan

DESIGN COMPANY
Brazen

COUNTRY OF ORIGIN
Singapore

WORK DESCRIPTION
Four postcards

DIMENSIONS
**175 x 140 mm
6⅞ x 5½ in**

e te feugait nulla faci

www.brazen.com.sg

1 | XXIᵉ troisième

philippe apeloig vous souhaite une heureuse année

DESIGNER
Philippe Apeloig

DESIGN COMPANY
Apeloig Design

COUNTRY OF ORIGIN
France

WORK DESCRIPTION
Posters to celebrate New Year 1998 and 2001

DIMENSIONS
**420 x 594 mm
16½ x 23⅓ in**

Struktur Design – Perpetual Kalendar

DESIGNER
Roger Fawcett-Tang

DESIGN COMPANY
Struktur Design

COUNTRY OF ORIGIN
UK

WORK DESCRIPTION
'Perpetual' wall calendar

DIMENSIONS
210 x 210 mm
8 1/4 x 8 1/4 in

80

81

DESIGNER
Ashley McGovern

DESIGN COMPANY
Pdp Graphic Design

COUNTRY OF ORIGIN
UK

WORK DESCRIPTION
Brochure

DIMENSIONS
265 x 372 mm
10 1/2 x 14 2/3 in

Contents: 4 & 5 introduction | 6 & 7 identity | 8 & 9 theatre publicity | 10 & 11 educational publicity | 12 & 13 overview |

introduction

identity

DESIGNER
Ashley McGovern, Paul Cowen, Nicola North, and Hayley Leaf

DESIGN COMPANY
Pdp Graphic Design

COUNTRY OF ORIGIN
UK

WORK DESCRIPTION
Website

DIMENSIONS
Website

theatre publicity

education publicity

websites

identity & branding

DESIGNER
Charles Wilkin

DESIGN COMPANY
Automatic Art and Design

COUNTRY OF ORIGIN
USA

WORK DESCRIPTION
Promotional postcards and larger cards featuring design work for both print and web

DIMENSIONS
Postcards: 102 x 153 mm
4 x 6 in
Larger cards: 140 x 145 mm
5 1/2 x 5 3/4 in

87

88

DESIGNER
Charles Wilkin

DESIGN COMPANY
Automatic Art and Design

COUNTRY OF ORIGIN
USA

WORK DESCRIPTION
Promotional cards featuring design work for both print and web

DIMENSIONS
140 x 145 mm
5½ x 5¾ in

89

DESIGNER
Anthony De Leo and Scott Carslake

DESIGN COMPANY
Voice Design

COUNTRY OF ORIGIN
Australia

WORK DESCRIPTION
Set of four postcards

DIMENSIONS
**105 x 150 mm
4 x 6 in**

DESIGNER
Anthony De Leo and Scott Carslake

DESIGN COMPANY
Voice Design

COUNTRY OF ORIGIN
Australia

WORK DESCRIPTION
Double sided poster promoting the company website

DIMENSIONS
594 x 420 mm
23¹⁄₃ x 16½ in

www.voicedesign.net

1. envision
2. inspire
3. ignite

DESIGNERS
Don Hollis and Paul Drohan

DESIGN COMPANY
Hollis Design

COUNTRY OF ORIGIN
USA

WORK DESCRIPTION
Promotional folder (front cover, far left; back cover, left; inner spread, below)

DIMENSIONS
**217 x 280 mm
8 1/2 x 11 in**

95

FIRM	**HOLLIS**	CONTACT	**619.234.2061**	VOLUME
PROJECT	ICONOGRAPHIC REVIEW	DIVISION	QUALITY PARTS DIVISION	2

DESIGNERS
Don Hollis and Paul Drohan

DESIGN COMPANY
Hollis Design

COUNTRY OF ORIGIN
USA

WORK DESCRIPTION
Identity sheets and 'Eye Candy' booklet

DIMENSIONS
Identity sheets: 217 x 280 mm
8 ½ x 11 in
Booklet: 88 x 88 mm
3 ½ x 3 ½ in

98

DESIGNER
Deanne Cheuk

DESIGN COMPANY
Neomu

COUNTRY OF ORIGIN
USA

WORK DESCRIPTION
Book showcasing work from designers around the world

DIMENSIONS
**110 x 110 mm
4 1/3 x 4 1/3 in**

99

DESIGNER
Dirk Uhlenbrock

DESIGN COMPANY
Signalgrau

COUNTRY OF ORIGIN
Germany

WORK DESCRIPTION
Postcards and small promotional cards

DIMENSIONS
Postcards: 105 x 148 mm
4 1/8 x 5 7/8 in
Small cards: 49 x 69 mm
1 7/8 x 2 3/4 in

101

radio01.net und gruppe taktischklug präsentieren

taktischklub

14. – 20. August 2000 ab 21 uhr
SIXPACK, Aachenerstraße 22, 50672 Köln

Dein Puls ist Dein Radio

Code:

DESIGNER
Dirk Uhlenbrock

DESIGN COMPANY
Signalgrau

COUNTRY OF ORIGIN
Germany

WORK DESCRIPTION
Change of address card (top left) and promotional flyers

DIMENSIONS
Various

DESIGNER
Marco Simonetti, Ibrahim Zbat, and Walter Stähli

DESIGN COMPANY
Walhalla

COUNTRY OF ORIGIN
Switzerland

WORK DESCRIPTION
Company information box and brochure

DIMENSIONS
Various

105

DESIGNER
Marco Simonetti, Ibrahim Zbat, and Walter Stähli

DESIGN COMPANY
Walhalla

COUNTRY OF ORIGIN
Switzerland

WORK DESCRIPTION
Website

DIMENSIONS
Website

107

DESIGNER
Marco Simonetti, Ibrahim Zbat, and Walter Stähli

DESIGN COMPANY
Walhalla

COUNTRY OF ORIGIN
Switzerland

WORK DESCRIPTION
Postcards and poster (below)

DIMENSIONS
Postcards: 136 x 270 mm
$5^{1}/_{3}$ x $10^{2}/_{3}$ in
Poster: 588 x 174 mm
$23^{1}/_{8}$ x $6^{7}/_{8}$ in

109

DESIGNERS
Chris Beer, Sam Wiehl,
and David Hand

DESIGN COMPANY
Splinter

PHOTOGRAPHER
Mark McNulty

COUNTRY OF ORIGIN
UK

WORK DESCRIPTION
Individual project cards
within cardboard case

DIMENSIONS
Case: 94 x 164 mm
3³/₄ x 6¹/₂ in
Cards: 90 x 125 mm
3¹/₂ x 4⁷/₈ in

splinter

ADDRESS THE GREENHOUSE – 308 LIVERPOOL PALACE
6-10 SLATER STREET LIVERPOOL L1 4BS UK
TELEPHONE +44 (0)151 709 9066
FACSIMILE +44 (0)151 709 9077
E-MAIL design@splinter.co.uk
WEBSITE www.splinter.co.uk

ANIMATION GRAPHIC DESIGN ILLUSTRATION INTERIOR NEW MEDIA PHOTOGRAPHY
PRODUCT 3-D DIGITAL MODELLING WEB CREATIVE THOUGHT

DESIGNERS
Chris Beer, Sam Wiehl, and David Hand

DESIGN COMPANY
Splinter

PHOTOGRAPHER
Mark McNulty

COUNTRY OF ORIGIN
UK

WORK DESCRIPTION
Project cards

DIMENSIONS
**90 x 125 mm
3 1/2 x 4 7/8 in**

113

Niels Hemmingsensgade 32A DK-1153 COPENHAGEN K
T: +45 33 32 04 03 F: +45 33 32 04 61
www.onco-type.dk

DESIGNERS
Morten Westermann and Morten Schjøot

DESIGN COMPANY
Oncotype APS

COUNTRY OF ORIGIN
Denmark

WORK DESCRIPTION
Gatefold booklet (front cover, above left; back cover, above; spread, above right; full gatefold, right)

DIMENSIONS
**106 x 148 mm (folded)
4 1/8 x 5 7/8 in**

oncotype er en digital design gruppe

[on]

ype er en interaktiv design gruppe

der arbejder med at skabe sammenhæng mellem det trykte og digitale medie

ncotyp-
e]

Computeren er kamæleonisk. Er den et magasin eller et TV,
et værktøj, en labyrintisk bog, et indkøbscenter eller en ny
potentiel livsform?
Hvordan skaber man design for sådan et kamæleonisk medie?

Interaktivitet: Lytte, tænke, tale - opfattelse, overvejelse, reaktion - interface, indhold, navigation. Digital design handler om

72% FLÜSSIG
DIE MENSCHEN UND IHRE AGENTUR

Ein Großteil der Erde ist mit Wasser bedeckt.
Das bedeutet nicht, dass alle nur mit Wasser kochen müssen.

Carina Orschulko und Ilja Sallacz haben die Agentur LIQUID im
Oktober 1999 mit dem anspruchsvollen Ziel gegründet,
pure Qualität und Kreativität zu bieten.
Damit wurde die Designschmiede in sehr kurzer Zeit bekannt.
Schnell avancierte der Hot Shop zur Full-Service-Agentur mit
mehreren Mitarbeitern und zwei klaren Vorteilen:
beständige Initiative für den Kunden und taufrische Ideen.

DESIGNER
Ilja Sallacz and Carina Orschulko

DESIGN COMPANY
Liquid

PHOTOGRAPHER
Andreas Brücklmair

COUNTRY OF ORIGIN
Germany

WORK DESCRIPTION
Foldout printed case (opposite page) enclosing individual project cards (this page)

DIMENSIONS
**Case: 172 x 160 mm
6³⁄₄ x 6¹⁄₃ in
Cards: 170 x 160 mm
6²⁄₃ x 6¹⁄₃ in**

117

118

DESIGNER
Amy Franceschini and Sascha Merg

DESIGN COMPANY
Future Farmers

COUNTRY OF ORIGIN
USA

WORK DESCRIPTION
Cover of CD-ROM containing promotional interactive material (top left); invitation to launch party (left); small promotional cards

DIMENSIONS
Various

119

DESIGNER
Rafael Esquer and
Wendy Wen

DESIGN COMPANY
@radical.media

COUNTRY OF ORIGIN
USA/UK

WORK DESCRIPTION
Change of address
card (front and back)
mailed out after a fire
at the company's
London office

DIMENSIONS
178 x 127 mm
7 x 5 in

AFTER THE FIRE...

@radical.media
has finally relocated
to our new
permanent home.

PLEASE NOTE

140 Wardour Street London W1F 8ZT
Tel 020 7432 6800 Fax 020 7432 6899
info@radicalmedia.com

@radical.media

New York | Los Angeles | London | Paris | Sydney

Thankfully no one was hurt. And hopefully many of you will come and visit us in our new space.

DESIGNER
Zip Design

DESIGN COMPANY
Zip Design

PHOTOGRAPHER
Caroline Moorhouse (cover)

COUNTRY OF ORIGIN
UK

WORK DESCRIPTION
Wire bound booklet
(cover and first spread)

DIMENSIONS
148 x 210 mm
5 7/8 x 8 1/4 in

122

123

ZIP

DESIGNER
Zip Design

DESIGN COMPANY
Zip Design

COUNTRY OF ORIGIN
UK

WORK DESCRIPTION
Wire bound booklet

DIMENSIONS
148 x 210 mm
5 7/8 x 8 1/4 in

EXPLICITLY MOOT

INSTRUCTIONS ON REVERSE OF THIS CARD

DETATCH THE CARDS AND PLACE THEM AROUND YOUR PHONE.

WHEN YOU FEEL THAT NEED - CALL MOOT DESIGN ON - ZERO ONE ONE SIX, TWO THREE FIVE, SEVEN SEVEN, FOUR NINE.
(OUR INTERNATIONAL FRIENDS SHOULD REMOVE THE ZERO AND INSERT FORTY FOUR AT THE BEGINNING)

UNADULTERATED EMI RECORDS BY MOOT

DESIGNER
Nitesh Mody

DESIGN COMPANY
Moot

COUNTRY OF ORIGIN
UK

WORK DESCRIPTION
Booklet containing tearout cards.
Front cover (left); back cover (right);
cards (below)

DIMENSIONS
162 x 100 mm
6 1/3 x 4 in

CATERS FOR MANY PERVERSE TASTES
GO ON TOUCH THAT MOOT
FOR VARIOUS STYLES OF STIMULATION
DIAL +(44) (0)116 235 7749

MOOTS' PRIVATE OBSESSION

127

DESIGNER
D-Fuse

DESIGN COMPANY
D-Fuse

COUNTRY OF ORIGIN
UK

WORK DESCRIPTION
Website

DIMENSIONS
Website

D-Fuse
CONTACT
3rd FLOOR. 36 GREVILLE ST. LONDON. EC1N 8TB. UK
MANAGEMENT T +44[0]20 74199445 F +44[0]29 74194980
EMAIL claire@dfuse.com STUDIO T +44[0]20 72533462
F +44[0]20 7253 3463 EMAIL design@dfuse.com

D-Fuse
FOCUS
- **D-Fuse** are a group of artists and media-experts generating concepts and visual data.
- **D-Fuse** are realizing concepts and tansmitting ideas throughout the whole media-scape.
- **D-Fuse** a-buse the tools of the digital revolution, filter the streams of data, experiment and develop a unique language for the needs of the digital world.
- **D-Fuse** output spans from time-based art to communicating ideas, from CYMK to RGB, from webconcepts to motion-graphics.
- **D-Fuse** art can be found in clubs, in print, on TV, on the web and on your screen.

D-Fuse
RE-VIEW
Around 1995 **D-Fuse** evolved out of "Chiarascuro", Scuro" and "Raw Paw" as one of the pioneers of webdesign in London. The realization of the Wire website - wich is known as one of the most comprehensive music related databases - and our network in the electronica music-scene led into **D-Fuse** becoming part of the forefront of club-visuals and installations. We worked together with musicians, such as Scanner, Ritchie Hawtin and Leftfield.
D-Fuse work has been shown internationally in various exhibitions and screenings, such as "Sonar" in Barcelona, "ISEA98", "Cities on the Move" in London (Hayward Gallery), "Experimentadesign99" in Lisbon and "OneDotZero". We produce Music Videos that are shown on MTV and Viva and created idents for BBC2, XFM Radio, the BFI and the japanese telecommunications company DoCoMo.

D-Fuse
VIEW

129

DESIGNER
Anna Berkenbusch, Svenja Plaas, and Tina Wende

DESIGN COMPANY
Anna B. Design

COUNTRY OF ORIGIN
Germany

WORK DESCRIPTION
Stamps, stickers, and labels

DIMENSIONS
Various

Schönes Fest …

Gutes neues Jahr!

zweitausendundeins:

Anna B. Design
Erkelenzdamm 11–13
10999 Berlin
Telefon 030/694 83 81
Fax 030/692 25 96

Anna B. Design
Erkelenzdamm 11–13
10999 Berlin
Telefon 030/694 83 81
Fax 030/692 25 96

Kirsten Wetzel

Anna B. Design
Erkelenzdamm 11–13
10999 Berlin
Telefon 030/694 83 81
Fax 030/692 25 96

Anna B. Design
Erkelenzdamm 11–13
10999 Berlin
Telefon 030/694 83 81
Fax 030/692 25 96

Anna B. Design
Erkelenzdamm 11–13
10999 Berlin
Telefon 030/694 83 81
Fax 030/692 25 96

Anna B. Design
Erkelenzdamm 11–13
10999 Berlin
Telefon 030/694 83 81
Fax 030/692 25 96

mail@annabdesign.de

mail@annabdesign.de

Neu!
mail@annabdesign.de
www.annabdesign.de

mail@annabdesign.de
www.annabdesign.de

Neu!
Fax 030/69 04 28 18
anna@annabdesign.de

zweit ausendundeins:

„Ich denke ganz oft an den Krieg …"

Mit anderen Augen *Wanderausstellung*
Der Kosovokrieg aus der Sicht von Kindern
KinderKulturBrücke ins Kosovo
Ein Kulturprojekt von MaikäferFlieg e.V.
www.maikaeferflieg.de

Anna B. Design
Erkelenzdamm 11–13
10999 Berlin
Telefon 030/694 83 81
Fax 030/692 25 96
mail@annabdesign.de

Tina Wende

Anna B. Design
Erkelenzdamm 11–13
10999 Berlin
Telefon 030/694 83 81
Fax 030/692 25 96

DESIGNERS
Rob Crane and Martin Yates

DESIGN COMPANY
You Are Here

COUNTRY OF ORIGIN
UK

WORK DESCRIPTION
Set of four promotional cards

DIMENSIONS
148 x 210 mm
5 7/8 x 8 1/4 in

132

Design and Art Direction
5 Blenheim Street, London W1Y 9LB
Martin Yates 07968 035 747
Rob Crane 07973 838 956
www.youarehere.tv

DESIGNER
Anja Lutz

DESIGN COMPANY
Shift!

COUNTRY OF ORIGIN
Germany

WORK DESCRIPTION
Postcards within plastic pack and promotional balloon

DIMENSIONS
Various

134

shift! happens

ORIGEN: BERLIN

PRODUCTO: MAGAZINO

VARIEDAD: Shift!

CALIBRE: SUPERO

DESIGNER
Anja Lutz

DESIGN COMPANY
Shift!

COUNTRY OF ORIGIN
Germany

WORK DESCRIPTION
Various cards, stickers, and postcards

DIMENSIONS
Various

im Grunde meines Herzens, versuche ich die Welt aus einem anderen Winkel zu betrachten, als das so üblich ist. shift! ist da.

136

137

Whether your job requires images of stupefied Neanderthals, overexcited extraterrestrials, remote-controlled robots invented by time-travelling Victorian fops, denizens of the underworld with business savvy, artistically inclined sea captains driving jalopies, re-imagined versions of low-rent 1970s television characters, crime-fighting disco gangs, steroid-enhanced quarterbacks holding grudges, kittens, over-caffeinated children in a media-induced stupor, an endless parade of metaphorical depictions of e-commerce business situations, or near-sighted super-intelligent monkeys who cannot express themselves, Wassco is certainly the place to call.

DESIGNERS
Chip Wass and Scott Stowell

DESIGN COMPANY
Wassco/Open: A Design Studio

COUNTRY OF ORIGIN
USA

WORK DESCRIPTION
Website

DIMENSIONS
Website

138

Is everything produced by Wassco manufactured using only the latest PostScript™-enabled illustration technology?

Earlier in life, did the Wassco team watch many hours of Saturday-morning television?

Is there Wassco merchandise available for purchase?

Any more questions?

Wassco

Wassco
How may we help you?
contact
F.A.Q.s

WORLD OF WASSCO
THE MISSING LINKS
the only famous monkey reference site you'll ever need
index of famous monkeys

Wassco
HOTLINE
CENTRAL PLANT LOCATION
"ELECTRONIC MAIL"
TELE-FAX

139

Nutrition Facts

Serving Size 1 oz./28g (that's 50 balls!)

Servings 37

Calories 150　Fat Cal. 80

*Percent Daily Values (DV) are based on a 2,000 calorie diet

Amount/Serving	%DV	Amount/Serving	%DV
Total Fat 9g	14%	**Total Carb** 16g	5%
Saturated Fat 2.5g	13%	Dietary Fiber <1g	2%
Cholesterol 0mg	0%	Sugars less than 1g	
Sodium 260mg	11%	**Protein** 2g	
Vitamin A 0%	•	Vitamin C 0%	
Calcium 0%	•	Iron 0% (e.g. nothing)	

Ingredients: Corn Meal, Cottonseed Oil, Buttermilk Solids, Good Feelings (love, friendship, altruism, awkward crushes), Cheddar Cheese (milk, cheese culture, salt, enzymes), Maltodextrin, Butter, Salt, Dash of I-Don't-Know-What, Sodium Phosphate, Monosodium Glutamate, Something Else That's Really Great, Natural and Artificial Flavor, Supernatural Flavor, Sour Cream [(cream, nonfat milk, cultures], cultured nonfat milk, lactic acid, citric acid), Artificial Color (including yellow 6 lake, yellow 5 lake, annatto), Touch of Whimsy, Lactic Acid, Secret Ingredient 67453, Hydrolyzed Corn Gluten, and so on.

WASSCO™ / CHIP WASS ILLUSTRATION
(212) 741-2550　www.worldofwassco.com

DESIGNER
Chip Wass

DESIGN COMPANY
Wassco

COUNTRY OF ORIGIN
USA

WORK DESCRIPTION
Jar of Cheetos cheese snacks

DIMENSIONS
235 x 330 mm
9 1/4 x 13 in

INDEX

@Radical.Media 120
Anna B. Design 130
Apeloig, Philippe 64, 78
Apeloig Design 64, 78
Ashworth, Chris 16–19
Auerlich, Heike 34–39
Automatic Art and Design 86–89
Beer, Chris 110-113
Berkenbusch, Anna 130
Benson, Paula 54–57
Brazen 76
Brücklmair, Andreas 116
Carslake, Scott 90–93
Carter, Neil 16–19
Cheuk, Deanne 98
Cowen, Paul 84
Crane, Rob 132
Cunningham, Paul 44–47
D-Fuse 128
De Leo, Anthony 90–93
Drohan, Paul 94–97
Eg.G 16–19
Eiche, Ilka 34–39

Eiche Oehjne Design 34–39
Esquer, Rafael 120
Ehline, Hajdeja 40–41
Extense 60–63
Fawcett-Tang, Roger 80
Feldmann, Eva 34–39
Form 54–59
Franceschini, Amy 118
Future Farmers 118
Gloesener, Tom 48
Godz 24
Grant, Jason 10–15
Graphic Havoc avisualagency 50–53
H55 144
Hanson Ho 144
Hand, David 110-113
Hemmingfield, Paul 16–19
Hilton, Chris 54–57
Hollis Design 94–97
Hollis, Don 94–97
Hunt, Richard 20–23
Inkahoots 10–15
Jerveys, Niall 42–47

Kerr, Russel 10-15
Leaf, Hayley 84
Liquid 116
Lutz, Anja 134-137
McDonald, Robyn 10-15
McNulty, Mark 110-113
McGovern, Ashley 82-85
Mangan, Ben 10-15
Merg, Sascha 118
Mody, Nitesh 126
Moot 126
Moorhouse, Caroline 122
Nael, Shahrokh 42
Neomu 98
Nofrontiere Design 66-69
North, Nicola 84
Oehjne, Peter 34-39
Oncotype APS 114
Open: A Design Studio 138
Orschulko, Carina 116
Pdp Graphic Design 82-85
Pentagram 70-75
Plaas, Svenja 130

Raban, Dom 16-19
Raybould, Scott 20-23
Rixford, Christie 40-41
Ruiz + Company 30-33
Ruiz, David 30-33
Sallacz, Ilja 116
Sanchez, Daniel 26-29
Sanchez, Jose Maria 26-29
Schumacher, Dirk 24
Schjøot, Morten 114
Shift! 134-137
Siddle, John 54-57
Signalgrau 100-103
Simonetti, Marco 104-109
Smith, Dave 16-19
Splinter 110-113
Stähli, Walter 60-63, 104-109
Stowell, Scott 138
Struktur Design 80
Super Natural Design 40-41
Tan, Alvin 76
The Design Unit (TDU) 42-47
Tillmann, René 24

Uhlenbrock, Dirk 100-103
Uniform 58
Vidale Gloesener 48
Vidale, Silvano 48
Voice Design 90-93
Walhalla 104-109
Walker, Pat 16-19
Wass, Chip 138-141
Wassco 138-141
Wen, Wendy 120
Wende, Tina 130
West, Paul 54-57
Westermann, Morten 114
Wiehl, Sam 110-113
Wilkin, Charles 86-89
Yates, Martin 132
You are here 132
Z3 Limited 20-23
Zbat, Ibrahim 104-109
Zip Design 122-125

DESIGNER
Hanson Ho

DESIGN COMPANY
H55

COUNTRY OF ORIGIN
Singapore

WORK DESCRIPTION
Balloons

DIMENSIONS
128 x 165 mm
5 x 6½ in

me me me me me me me me me me me me me me me